the KODAK Workshop Series
Close-Up Photography

Written for Kodak by William White, Jr.

the KODAK Workshop Series

Helping to expand your understanding of photography

Close-Up Photography

Written for Kodak by William White, Jr. and including articles,
*Close-Focus Field Photography with Large-Format Cameras,
A Personal Account* by Dennis Brokaw and *Photographing Miniatures*
by Malcolm Furlow.

Cover Photo by Dean Pennala – KINSA/KODAK Photo Contest

Publication KW-22
CAT No. E144 1161
Library of Congress Catalog Card Number 95-67554
ISBN 0-87985-750-1

3-95 Minor Revision

Printed in the United States of America

The Kodak materials described in this book are available from
those dealers normally supplying Kodak products. Other materials
may be used, but equivalent results may not be obtained.

KODAK is a trademark of Eastman Kodak Company used under license.
KODACHROME, EKTACHROME, EKTACOLOR, ESTAR, EKTAPAN, LUMIERE, PLUS-X,
TRI-X, EKTAR, T-MAX, GOLD, ROYAL, and WRATTEN are trademarks of
Eastman Kodak Company.

KODAK Books are published under
license from Eastman Kodak Company by
Silver Pixel Press
21 Jet View Drive
Rochester, NY 14624
Fax: 716-328-5078

Contents

Close-up!

Flowers, eyes, honey bees and butterflies! Many of life's most captivating sights are miniatures. In fact, this is probably the reason that miniatures themselves have always been so popular. They provide a world that we can appreciate, handle and control on our own. Tiny scenes can be photographed and miniature worlds recorded with the techniques you will learn in this book.

Just read the text which presents the established principles and follow the illustrations with your own camera, simple or complex, and with some practice and patience you can get the same results. You can record your most captivating sights on film.

EYE: The original "camera" and the basic reason for this book—and all books and pictures—for without its existence there would be no necessity for light, dark, or beauty. In itself, isn't the human eye a thing of exquisite loveliness?

Photographed through a 55 mm MICRO NIKKOR Lens with natural light on KODAK EKTACHROME 200 Film.

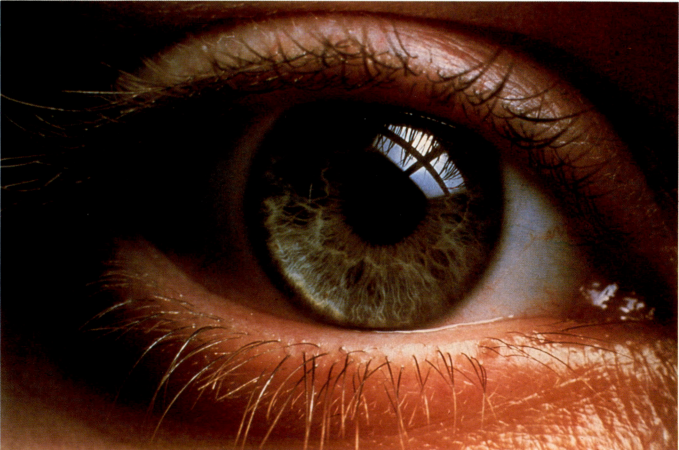

Jean-Paul LaSalle

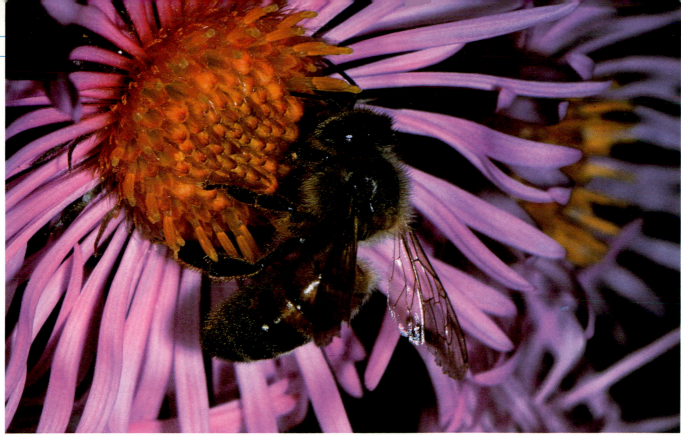

Dwight R. Kuhn

FLOWER: This lovely backlighted rose is an example of close-focus photography with a telephoto lens. The lens used was a NIKKOR 600 mm ED IF with a NIKKOR 1.4 Extender, making the actual focal length 840 mm. Exposure was 1/60 sec at f/5.6. A sturdy tripod was essential for such a focal length.

HONEYBEE: Gathering nectar from a wild aster, the insect was captured with a 90 mm macro lens and a 1:1 macro adapter on 35 mm film. Exposure was 1/80 sec at f/16. A single flash was mounted above the lens about 8 inches from the subject.

BUTTERFLY: A Monarch rests on the flower of a thistle. Photographed with electronic flash used to light only the butterfly. To darken the background, the flash must overpower the ambient light. Also, use a small enough aperture to decrease the maximum distance of the flash range so the background will not be illuminated.

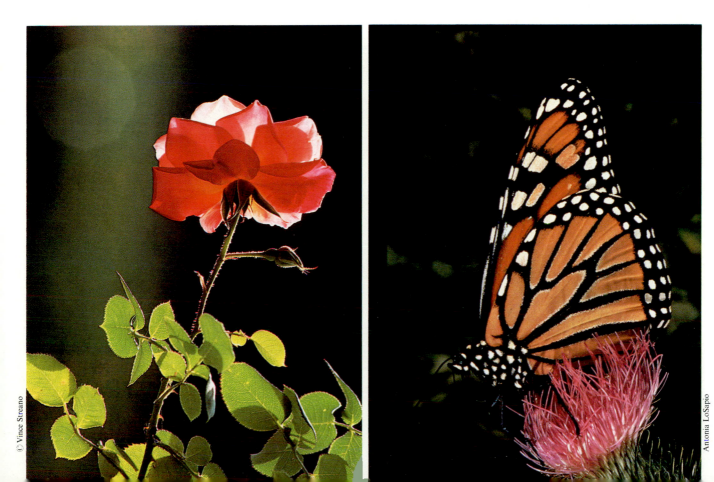

© Vince Streano

Antonia LoSapio

Close-up photography may be divided into three distinct ranges in which photographs can be taken but require distinctly different equipment and techniques.

CLOSE-FOCUS (WITHOUT ACCESSORIES)

Most of the commonly available 35 mm single-lens-reflex (SLR) cameras use a 50 mm focal length lens for everyday picture-taking. Such a lens will focus as close as 60 cm (approximately 24 inches) to the subject. At this distance a small pet, an antique vase, or a child's head will fill the frame. To get any closer to the subject and keep it in focus, the camera must be equipped with some accessory device.

For a discussion of larger-than-35 mm camera techniques, see Dennis Brokaw's article, *Close-Focus Field Photography with Large-Format Cameras, a Personal Account,* starting on page 32.

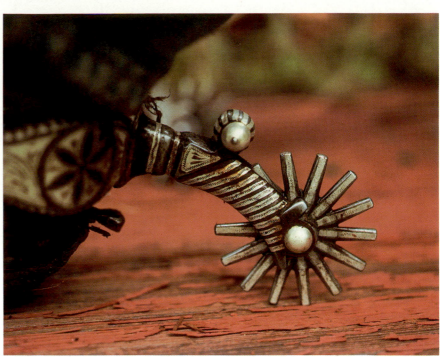

© Vince Streano

Another example of close-focus work. The photographer happened to see these beautiful Mexican boots and spurs on the feet of a local cowboy. He made the photograph without further manipulation, using a NIKKOR 105 mm lens. Exposure: 1/125 sec at f/8.

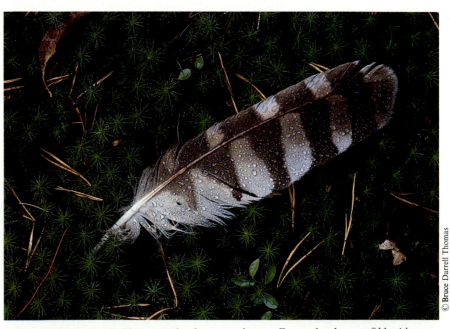

© Bruce Darrell Thomas

A "found composition." This example of close-focus photography, a dew-covered feather of a Barred Owl on the soft forest ground cover, conjures visions of a wildlife drama. Exposed at 1 sec at f/11 with a 100 mm macro lens and a bellows on a 35 mm SLR. Soft, natural light was provided by an overcast morning sky.

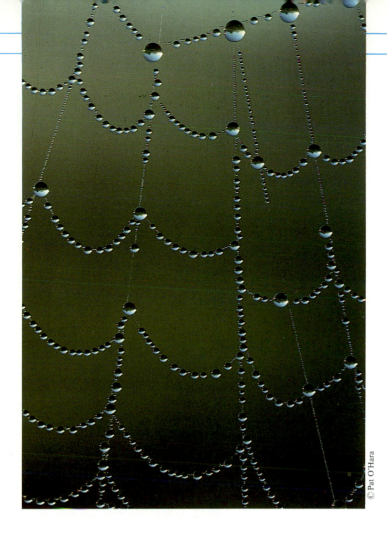

CLOSE-UP

True close-up begins where the closest focus of the standard lens leaves off (at about 1/10 actual size) and extends to a reproduction or image ratio of 1:1 or 1 × — what we normally call "life-size," where the image on the film is the same size as the subject in life.

A true example of close-up photography. Here is an example of 1:1 magnification; shallow depth of field, and natural "strings of pearls." Photographed early on an overcast day with a SLR, a 50 mm macro lens and a 25 mm extension tube on KODACHROME 25 Film. Exposure: 1/2 sec at f/8.

© Pat O'Hara

© Pat O'Hara

The "string of pearls" is transformed to diamonds by Mother Nature's change of temperature. Exposure was 1/4 sec at f/8 in diffused sunlight using the same equipment as in the photograph above.

ULTRA CLOSE-UP

Images greater than life-size involve an actual magnification (reproduction ratio greater than 1:1). This requires a different series of accessories and very precise techniques to extend the range of the 35 mm SLR, usually to about 6× as a maximum of enlargement.

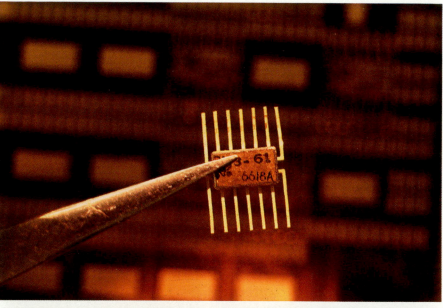

The use of selective focus was to emphasize the computer chip and its relationship to the mother board. Handheld at 1/15 sec, f/3.5, and a 55 mm MICRO-NIKKOR lens with a CC20M filter. The photo was made for the Texas Instrument Corporation and used in an annual report.

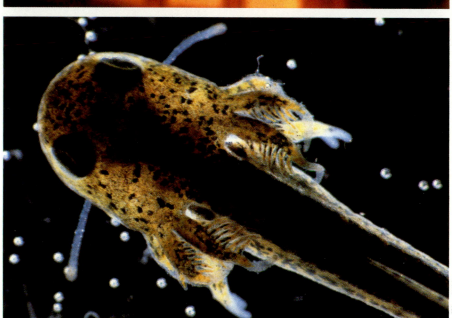

Ultra close-up photography, larger than 1:1 magnification. A newly hatched amphibian, on a dark field (see page 63) with transmitted light. The LEICA R3 Camera with a MACRO ELMARIT Lens in an extension bellows. Effective aperture of f/22, at 1/8, sec produced a 3× magnification on KODAK EKTACHROME 64 Film. Reproduced here at 10.8×.

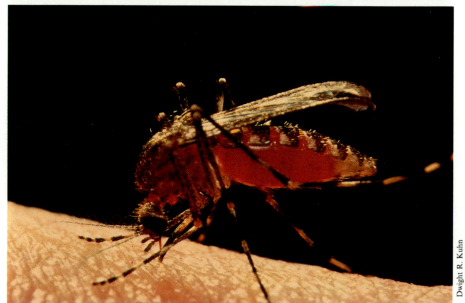

A New Jersey mosquito? This handsome portrait of a hungry lady was made with a bellows extended to 80 mm and a 55 mm MICRO-NIKKOR lens reverse-mounted. The exposure was 1/80 sec at f/16. A single, small flash was positioned above and behind the subject at about 8 inches. The female mosquito was coaxed onto the photographer's left index finger after buzzing around his head. When it began feeding, he moved his hand in front of the camera set-up. What dedication!

Tom Carroll

Wm. White

Dwight R. Kuhn

PHOTOMACROGRAPHY

This is the special branch of technical photography that builds on the principles of ultra close-up and requires many more calculations; it encompasses magnification ranges up to about 50×. It requires special techniques with three-dimensional objects, and can produce photographs so highly magnified that features become visible which are not normally visible to the unaided eye. This technique is beyond the scope of most standard photographic equipment and is not covered in this book.

Photomacrography: Top right: This photo of an embryonic pipefish was taken with a darkfield background and a WILD-HEERBRUGG M-400 Camera, 1/2 aperture, and fiber-optic lights at 1/20 sec on KODAK EKTACHROME 160 Film (Tungsten). The original magnification was 4×. It is reproduced here at 14.4×.

Often, a corporate annual-report photographer must shoot under very limiting conditions. The optical bench (Figure A) was in a research office. The object in its frame is a LIGHT MOD™ by Litton Industries Data Systems Division, a new display device for computers. On the face of the Magnito-Optic Device, information is displayed in arrangements of yellow pixels that are .003-inch in diameter (Figure B), almost invisible without a microscope.

The overall view was taken with a 24 mm EL NIKKOR Lens, 1/30 sec at f/5.6, with a CC 30 M filter on KODAK EKTACHROME 200 Film, pushed 1 stop. A small microscope lamp, filtered, illuminated the face of the scientist. The close-up view was taken with a 55 mm MICRO NIKKOR Lens, 1/30 sec at f/4, through the lens of the light-bench micro system. Lighting was provided by a fiber-optic micro light with a No. 2.7 diffusion head on the front of the display unit and a spot head on the rear. Both photos were handheld and are on the same film.

Client: Litton Data Systems
Ad Agency: Knoth and Meads
Corp Coordinator: Jame Wolhowe

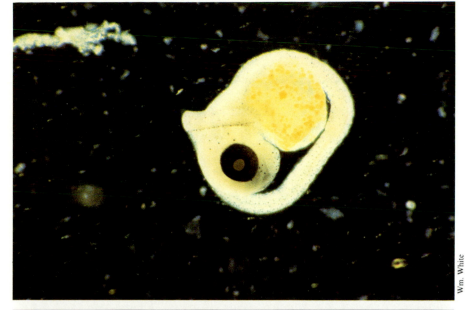

Wm. White

A

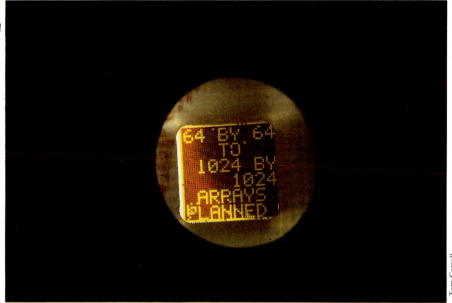

Tom Carroll

B

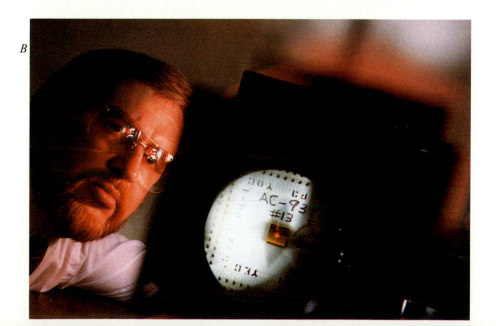

Basics of close-up photography

We are not only intensely inquisitive about the world in which we live, but intensely visual about that inquisitiveness. In all languages, one of our earliest expressions is "let me see!" At the same time, humans are among the larger living creatures of the earth. Most things and many phenomena are smaller, in whole or in part, than we are. For this reason, much of our everyday world is miniature or even tiny in comparison to ourselves.

The same compulsion to capture and hold a moment of time in our hands, that has made photography one of humanity's most common leisure activities, has caused close-ups to become a popular extension of photography. Once you understand the basics, you can produce close-ups indoors and out, in all seasons, with people, animals and hobbies, with sunlight and flash, in black-and-white, or in full color. But close-up photography's applications do not stop there. It is used more than any other laboratory method for serious scientific recording in almost every field of technical endeavor.

Most of these uses will be examined in this book along with the basic principles that govern them.

RULES OF THE ROAD

There are five simple rules that will govern you in learning how to take close-ups:

1. Know your camera well enough so that you can focus, set the aperture and shutter speed, make the exposure, and advance the film without thinking about the sequence.

2. Use a camera of the best quality you can obtain, but stick to those with simple and uncluttered designs.

3. Experiment with different angles and distances from the subject so as to view as many possibilities as you can before making the exposure.

4. Keep a written record of each exposure so that you can learn from both your successes and your failures. Your notes should include not only the film type and speed, but the aperture and shutter speed, the distance of the lens and camera from the subject, and the final magnification.

5. Plan your composition. Consider what feature you most want to show in the photograph. Concentrate on getting that main aspect on film!

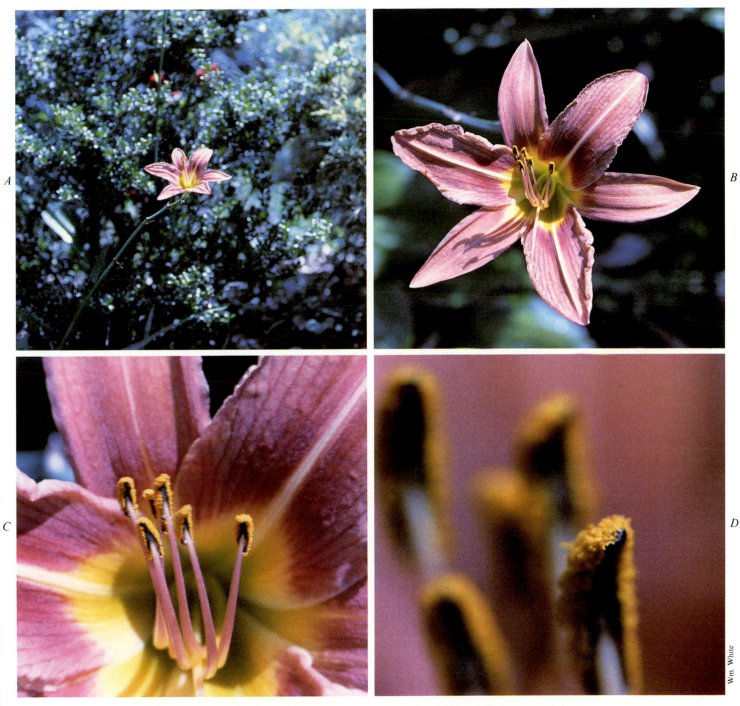

A series of photographs of a hybrid lily in subdued sunlight taken with a 60 mm MACRO-ELMARIT Lens: A), a 1:20 or more reduction, exposed at 1/125 sec, f/8; B), a 1:6 reduction, exposed at 1/80 sec, f/8; C), a 1:1 magnification, exposed at 1/80 sec, f/8; D), a 5:1 magnification, exposed at 1/4 sec, f/22 with a bellows and a 12/5 mm PHOTAR Lens. Note the very shallow depth of field, but the high degree of detail on the pollen in central focus. All photos reproduced here at a 4× increase in magnification.

Photographing miniatures

by Malcolm Furlow

I feel I have always had within me, a compelling urge to make representations of my environment, to sculpt or mold that which has been visually experienced, even to the point of attempting to portray the very spirit of the subject. But, at the same time, I lean heavily on imagination, that necessary ingredient in any creative effort with vitality to produce an illusion of real life.

The Denver and Rio Chama Western R.R.: An overall view of my HO-scale layout. The overhead lighting gives a somewhat cloudy day appearance to the scene. This type of lighting works well for general viewing.

Malcolm Furlow

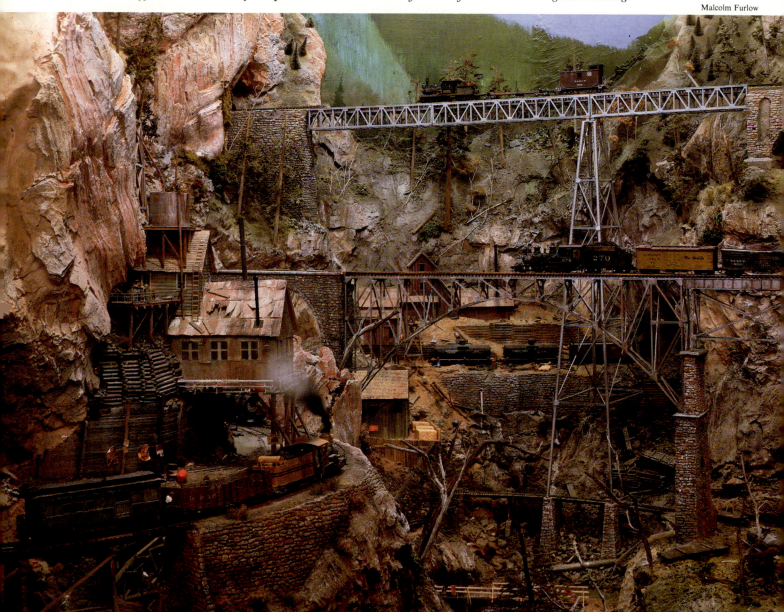

Early-on in my modeling career, I used an inexpensive 35 mm SLR camera, mainly to record progress on my sets and layouts; making sequential photographs to file away along with construction notes and manuscripts. Soon thereafter, using the camera as a tool for composition, I peered through the viewfinder for hours, to arrange sets, place the three-dimensional forms, and help to frame small vignette scenes towards the ultimately completed set. By introducing a camera to my modeling, I was able to draw tighter parallels between the real world and my miniature world.

If you are a student of history and a modeler, as I am, a camera can help you create photographs of your set that capture the charm and nostalgia of an earlier time. I have used darkroom techniques, like sepia toning and handwritten signatures on sheets of glass placed over black-and-white paper stock during enlargement, to produce nostalgic images, reminiscent of old glass-plate photographs.

Special effects can be combined within the area of model photography that give the feeling of movement; snowy landscapes, night time scenes, sunsets, and early morning composites, to name a few. Front- or rear-projected backgrounds can give miniatures depth and dimension. So photographing miniatures is an adventure in illusion, the limits of which are one's own imagination. Photographing miniatures is also big business—witness the creative effects associated with block-buster movies such as *Star Wars* and other Spielburg fantasies. Miniatures, and the effects that can be accomplished photographically with miniatures, can become a never-ending frontier of enjoyment and creativity.

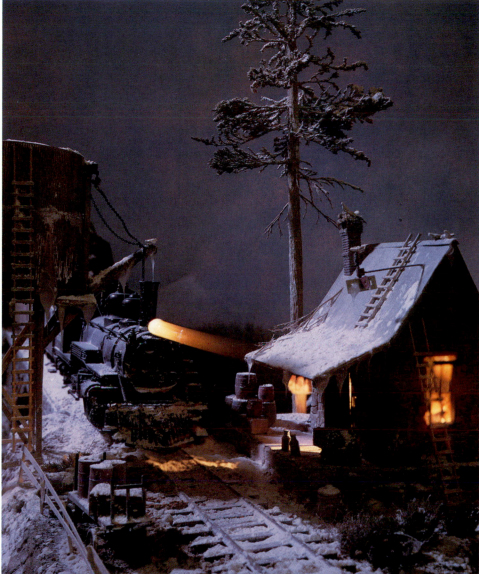

Malcolm Furlow

Winter in Coot's Gap: This photograph appeared on a cover of Model Railroader *Magazine.*

Two exposures were necessary to achieve this wintery night scene. A clear plastic soda straw was placed against the headlight on the engine and the first (2-minute) exposure was made at f/8. Then the shutter was closed, the floodlights turned on, the soda straw removed, and the second exposure of 4 minutes at f/64 made with a blue filter over the lens.

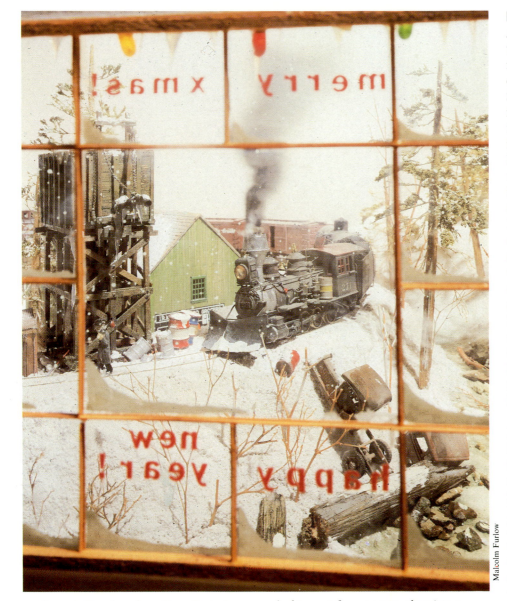

Malcolm Furlow

Season's Greetings from Days Past: A piece of 11 x 14-inch glass was positioned in front of the lens and white house paint "flicked" onto it to simulate snowflakes for this winter scene. Small pieces of wooden moulding in a framing pattern with plastic snow in the corners and backwards lettering complete the foreground and promote a cozy feeling of looking out from a warm place into a wintery world. The engine exhaust smoke is darkened cotton, moved during the 2-minute exposure.

Courtesy—Walthers, Inc.

EQUIPMENT

An easy way to get into model photography is with a 35 mm single-lens-reflex camera and, of course, a couple of trips to the hobby shop. I like using SLRs because usually "what you see is what you get." The actual image is focused through the lens and bounced into your eye via a mirror. Lenses that lend themselves to this type of close-up photography almost always fall into the "wide-angle" category. My own personal arsenal of lenses for my 35 mm camera could be considered quite modest. I rely on a 28 mm wide-angle lens for most small-format work. Occasionally I slip on a 50 mm, or a 24 mm lens, depending on the scene or the effect I am after. But, the 28 mm lens is a really good choice, especially for its excellent depth of field, as it seems to put the viewer a little deeper into the scene than does a normal lens. I have also used macro lenses with good results.

For medium-format work, I use a MAMIYA 6 x 7 cm Camera, mainly because of its larger negative size and the double-exposure feature it possesses, but the mainstay of my "color for publication" equipment is a LINHOF 4 x 5-inch View Camera. It's heavy, cumbersome, bad news to haul around, but I dearly love it. From controllable sharpness and distortion correction (or alteration) to an extreme depth of field, it has the capability, when combined with a good lens, to render an image with contrast, fidelity of detail, and resolution necessary for the recording on film of all the minute details and diminutive offerings that I spend so many hours laboring to sculpt into a scene. Notice, I mention the term "depth of field." It is probably the biggest problem associated with model photography. Here is something to remember; the shorter the focal length of a lens, the greater the depth of field (that which from close to the lens to far

from the lens will be sharp in the photograph). This fact is important when working with miniatures because of the relative smallness of the individual components, like a tiny HO-scale steam engine and its train. Moreover, the distance from the camera to the object itself is equally important. Most SLRs will focus down to about 1½ feet. The *f*-stop of the lens, along with the focal length, determine the overall sharpness of the photograph. Without my jumping off into a lot of technical rambling on the subject, just remember to "stop down" when photographing miniatures. For persons with 35 mm gear, this means, for pratical purposes, *f*/8 or *f*/11 depending on the lens. (See pages 26 through 31.) Of course, with my view camera, the lens will stop down to *f*/64, yielding a great amount of depth of field throughout the total scene because of the larger film size. This, coupled with distortion altering features called "swings and tilts" constitutes the reasons why this type of camera lends itself to photographing miniatures so well.

Along with depth of field, consider exposure. As you stop down the lens, you limit the amount of light reaching the film. Long exposures are necessary when photographing miniatures if you must have maximum depth of field. A good tripod and cable release are essential. Moreover, long color exposures can cause a real problem when using a view camera. Under normal lighting conditions the necessary long exposures resulting from stopping down the lens and extending the bellows on a view camera may require corrective filters to compensate for color shifts in the film.

What are normal lighting conditions in miniature model photography? Individual models can be positioned in dioramas, then placed outdoors to take full advantage of natural sunlight. However, a modeler

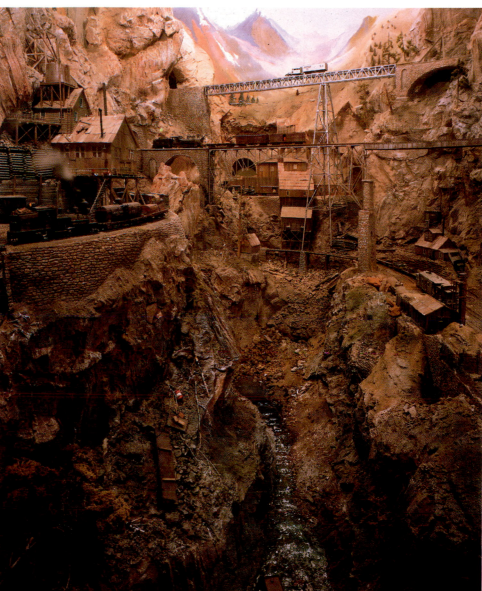

A vertical view of the Rio Chama showing floor-to-ceiling scenery.

Malcolm Furlow

such as myself, who has built an extensive layout in a garage or basement must resort to artificial light, and plenty of it! Before making an exposure, I remove all of the ordinary incandescent bulbs from behind the valence that borders the layout and replace them with 250-watt photofloods rated at 3200 Kelvin. I also use 1000-watt floodlights rated at 3200 K on large stands when shooting in my up-

stairs studio where the extra high ceilings make using these types of lights practical. Floods at 650 watts are directed, or bounced, into the scene with umbrellas for fill light, and white card stock is positioned here or there to reflect the fill light. White cards or umbrellas can be helpful in directing fill light when shooting outdoors, as well, especially when the sun is fairly high.

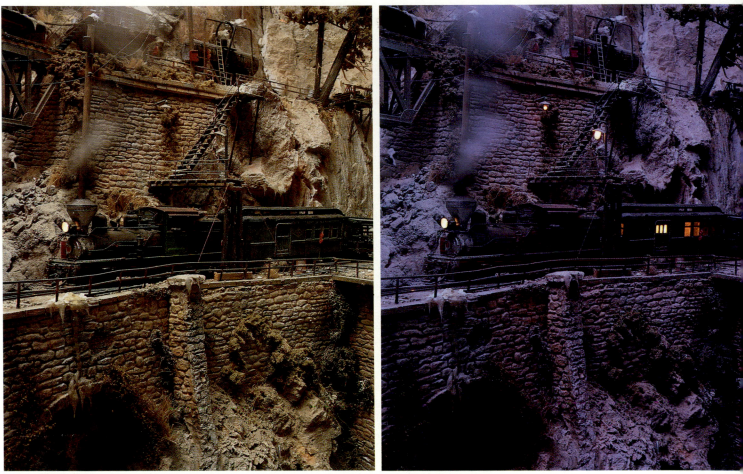

Malcolm Furlow

The Chama Creek Tank: I usually burn-in the locomotive headlight before making the normal exposure. This is done with all the floodlights turned out, and at a lens aperture of about f/8 for about 30 seconds. Then the shutter is closed, the floods turned on, and the normal exposure of 2 1/2 minutes is made, this time at f/64.

Here is the same scene photographed basically the same way, except all the building lights were burned-in along with the engine headlight and a blue filter was added to the lens for the second exposure.

FILM

Once I have finished building a diorama or arranging a scene for a photo session, it is time to load the camera, usually with color transparency stock. I use transparency films because my images are published. Most people reading this book, however, would probably use a color negative film if they are planning to have enlargements made. I usually like to use KODAK EKTACHROME 64T Professional Film that is balanced for tungsten light sources. This film's ISO rating of 64 translates into "slow speed, fine grain." Along with this particular film, I use POLAROID Film rated at the same ISO speed and balanced for tungsten light. This way, I can check exposure and composition with a few POLAROID Prints then switch to the color film without making filtration or speed changes. When using the 4 x 5-inch camera outdoors, a daylight-balanced film, such as KODAK EKTACHROME 64 Professional Film, is my choice.

If I am working indoors with the 6 x 7-cm camera, the variety of film stock that can be used for photographing miniatures becomes a bit greater, for along with the "slow" film stock, we now can add another tungsten-balanced film, with a faster ISO rating of 160. Kodak also markets "faster" tungsten and daylight-balanced color transparency films for the 120 format, but I prefer to stick with slower films and tighter grain.

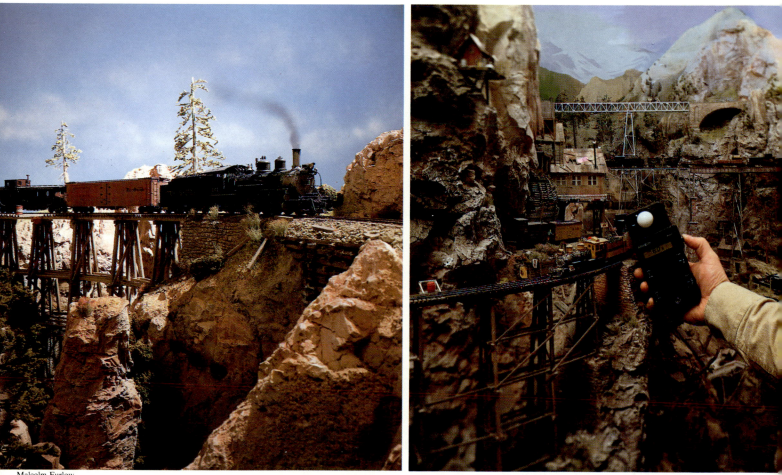

Malcolm Furlow

This section of a scale scene was taken outdoors. Notice the increased contrast.

Be sure to take numerous light readings throughout the scene to calculate the exposure—then bracket exposures on both sides of your best calculation.

Probably most modeler/photographers will be working with 35 mm SLRs. For this format I recommend using KODACHROME 40 Film 5070 (Type A) when working indoors. Although it is balanced for photofloods rated at 3400 Kelvin, I have used this film with lamps rated at 3200 K with excellent results. Kodak recommends an 82A filter. Of course, EKTACHROME Films can be purchased for the 35 mm format, and, when working outdoors, great results can be obtained with KODACHROME Film. When exposing black-and-white film, I use KODAK T-MAX 100 and 400 Professional Films all the time. They are a better film with greater latitude and tighter grain.

After taking numerous light readings with a handheld meter, I usually begin exposing film according to the light meter readings and bracket my exposures one stop above and one stop below the meter reading. When using a larger-format camera that allows the use of a POLAROID Back, the exposure can be calculated, then a sheet of POLAROID Film exposed to check everything. However, it is still a good idea to bracket exposures even if the POLAROID Print looks correct.

I usually focus about one-third into the scene and let depth of field carry the shot. (Note: This is correct close-focus photographic technique.)

Malcolm Furlow

Creating the exciting effect of exhaust smoke belching from the stacks of steam engines. The illusion is created by attaching one end of an elongated tuft of darkened cotton to the stack, the other end to a wire. The cotton is wiggled during the exposure (4 seconds or more), hopefully, without moving the engine itself.

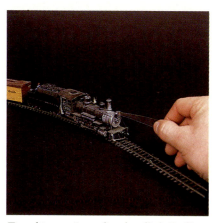

To achieve a "traveling headlight" effect, place a piece of thin, clear plastic or a soda straw against the lighted headlight. Turn off all other photo lights and "burn-in" the headlight with attached plastic for about 30 seconds at f/8 (for ASA 50 tungsten film). Then, close the shutter, stop down the aperture to f/32 or as far as possible, remove the plastic strip, turn on the photo lights and make the second normal exposure.

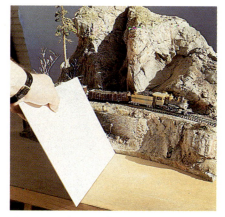

At times, when working outdoors, a little necessary fill light can be directed into shadows with a piece of white cardstock.

SPECIAL EFFECTS

When photographing one of my early-era train scenes, I sometimes like to create illusions of movement. Foggy morning scenes are neat, or how about a sunset or two? With a small teakettle steamer chuffing and puffing, black smoke bellowing out of a diamond stack as a vintage model makes its way through a realistically painted plaster canyon of my own creation, I can make my choice. All I need here is a piece of darkened cotton attached to a black-painted wire and a long exposure. The cotton is wiggled and jiggled during an exposure of five seconds or more. I am careful not to move the locomotive while all the wiggling and jiggling is in progress. This "smoke-photography" technique is sometimes better accomplished with an assistant—maybe a wife, husband, or a friend can trip the shutter while you jiggle the cotton, or vise versa. They will probably think you are crazy!

Two or more effects can be combined to produce exciting photographs, like *Early Morning in Silver Canyon*. During the exposure a combination of dry ice and cotton were used to give the photograph movement, and both electronic flash and floodlights were employed to illuminate the scene.

In a cover photograph for *Model Railroader Magazine*, a length of clear plastic soda straw was used to stretch the headlight beam, adding a touch of romance to the snowy night scene. The soda straw was attached to the front of the headlight and all of the floods turned out. The headlight in the engine was turned on, the straw attached, and a 1-minute exposure made with the aperture setting at f/8. At the end of the 1-minute first exposure, the shutter was closed and the floods turned back on. The straw was removed, the shutter recocked, and the aperture carefully moved to f/64. This time, for the second exposure, both the house and the engine—sans straw—were illuminated and a 4-minute exposure made. Oh yes, for the second exposure a blue gel was placed over the lens for a moonlight effect. I started to add the old cotton trick to the stack, but elected to go with the light beam only, not wanting to distract the viewer or clutter the image. A greater combination of ef-

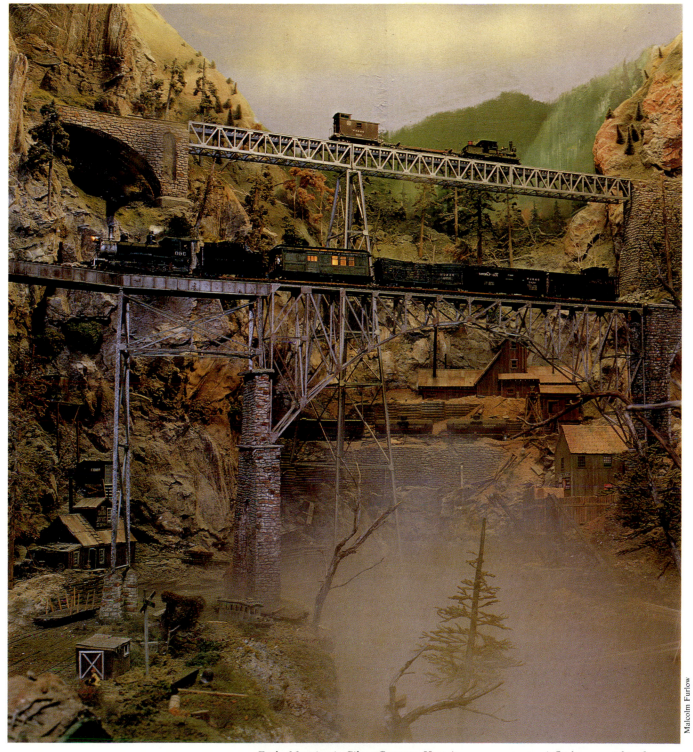

Malcolm Furlow

Early Morning in Silver Canyon: Here is an example of combined special effects— burning-in of the locomotive headlight and passenger car light, cotton exhaust smoke, and blowing in "dry-ice" fog, as well as mixed light sources—to achieve an exposure. A flash was used to freeze the dry-ice fog at the end of the exposure. A color-correcting filter was taped over the flash head to balance it with the tungsten floodlights.

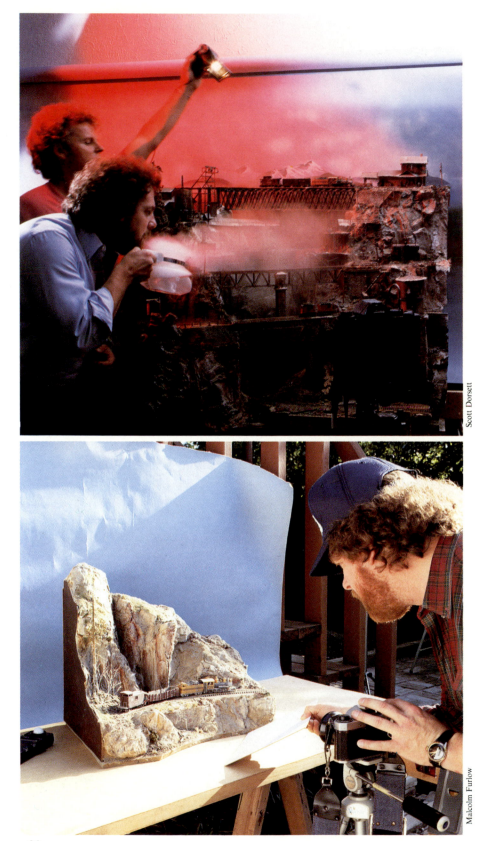

How to Simulate a Foggy Early Morning: Tape a red filter over the light source, boil some water and drop in some dry ice, tape a VIVITAR 283 Flash Unit with a tungsten correction filter, and make two exposures. You need at least 2 people—maybe 3—to pull this one off! (Billy Michael Haynes holding flash, Malcolm Furlow blowing dry-ice fog.)

Scott Dorsett

Malcolm Furlow

fects could have been used here. While making the first exposure using the soda straw, a wider aperture was used so that the "beam" of light would lose definition gradually as it "traveled" from the headlight fixture.

In creating another winter scene, I toyed with the idea of capturing falling snow. This photograph appeared in the 1981 *Walters Catalog* and featured a "snowfall" painted on a piece of glass placed in front of the lens.

If you are a modelist who has yet to use a camera as an extension of your creativity with miniatures, I promise that you will be hooked on creating special effects through the medium of photography. If you are a photographer who has built a model or two, be it a car, train, plane, or ship, try putting a small diorama or scene together for a session with your camera. I'll bet that you will be building more models and making more photographs! The effects discussed here are just a few that can be used over and over or in combination to produce photographs of startling realism using miniatures. Requirements—a model, a camera . . . imagination!

Sometimes, it is possible to remove a section of the layout and take it outdoors for photographic purposes. Use a large sheet of paper—white or colored—to eliminate unwanted background detail.

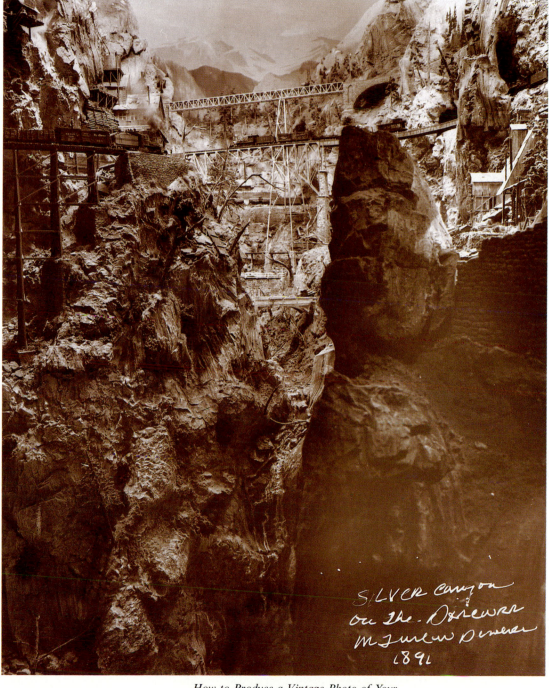

SILVER canyon on the D&RGWRR M Furlow Denver 1891

Malcolm Furlow

How to Produce a Vintage Photo of Your Layout: The written information was inscribed on a sheet of clean glass with a fountain pen and India ink. Then the glass was placed on top of the enlarging paper during the printing step.

Theory and formulae

Today's single-lens-reflex cameras, with their built-in capabilities to calculate the proper exposure directly in camera, no matter what accessory lenses or filters are in place, have simplified the process of obtaining correctly exposed close-focus photographs. With the most automated cameras, you simply set the exposure index, aim, and shoot. All calculations are done away with. However, for larger magnifications than are possible with normal SLR lenses, for owners of nonautomatic and large-format cameras, and for those readers who wish to know how to do it, the following photographic theory and formulae will be of great interest.

Unsuspected color and design is found in this cross-section of a communications wire bundle. A 3 × enlargement ratio. Exposure was 1/2 sec 1/2 aperture with a WILD-HEERBRUGG M-400 Camera on KODAK EKTACHROME 160 (Tungsten) Film. Reproduced here at 15.9 ×.

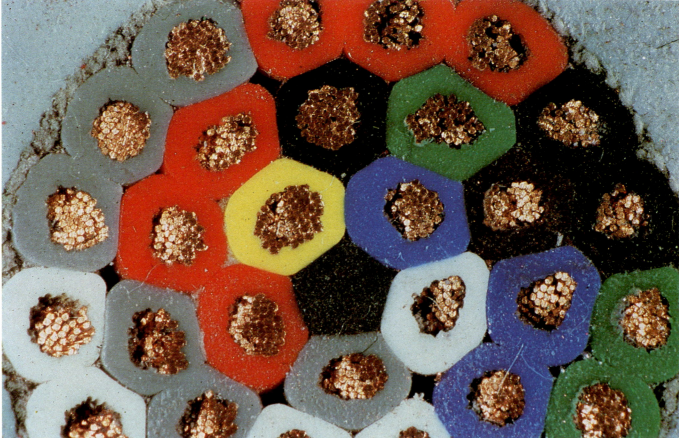

R. Gander

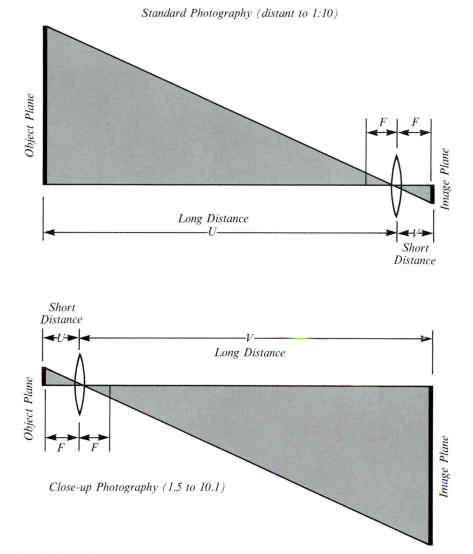

Standard Photography (distant to 1:10)

Close-up Photography (1.5 to 10.1)

Standard vs Close-Up Photography.

There are two general magnification ranges in close-up technique. The one we describe simply as "close-up" provides for the range from approximately 1/10-size to life-size. At 60 cm (24 inches) from the subject, the image will include an area in front of the camera in the subject plane of about 25 x 40 cm (9 1/2 x 16 inches); at 1:1 the image size of 24 x 36 mm (the standard 35 mm negative or transparency size) will cover exactly 24 x 36 mm in the object plane. With close-ups made at less than 1:1 (life-size), the distance between the film plane and the lens is shorter than the distance between the lens and the subject. But beyond 1:1, the distance between the lens and the subject becomes less than the distance between the lens and the film plane.

What we will call ultra-close-up, or photomacrography, extends the range of magnification from 1:1, to a definitely visible enlargement of the subject up to about 6 times life-size. Beyond that, it is more practical to use the techniques of photomicrography.

The technique of close-up photography requires an accessory lens to be attached to the front of the standard lens, a spacer to extend the standard lens, a reversal of the standard lens, or the use of a specially designed lens which can be extended to produce the magnification desired.

The technique of ultra-close-up photography requires specific types of viewing finders, or screens, in the camera, specific close-focusing lenses, and steady camera mountings for the long extensions required. The principles which govern each technique are rooted in the physical properties of light and the lenses that form the image on the film. While you may not understand them all at first, the more

you experiment with your camera and review the basic optical principles of close-up photography presented here, the clearer the requirements for this technique will become. Then you will be able to use and apply the tables to full extent, save time and film, and produce very satisfactory images on film.

There are seven concepts which comprise the basic optics of close-up photography. They are explained here in detail but they are reviewed throughout this book. They are . . .

- Magnification
- Depth of field
- Exposure increase factor
- Diffraction effects
- Resolution
- Contrast
- Image quality

Once you understand these concepts, you will be able to judge the object you wish to photograph and the kind of information or image you wish to show. Then you can weigh properly the close-up compromises that must be made.

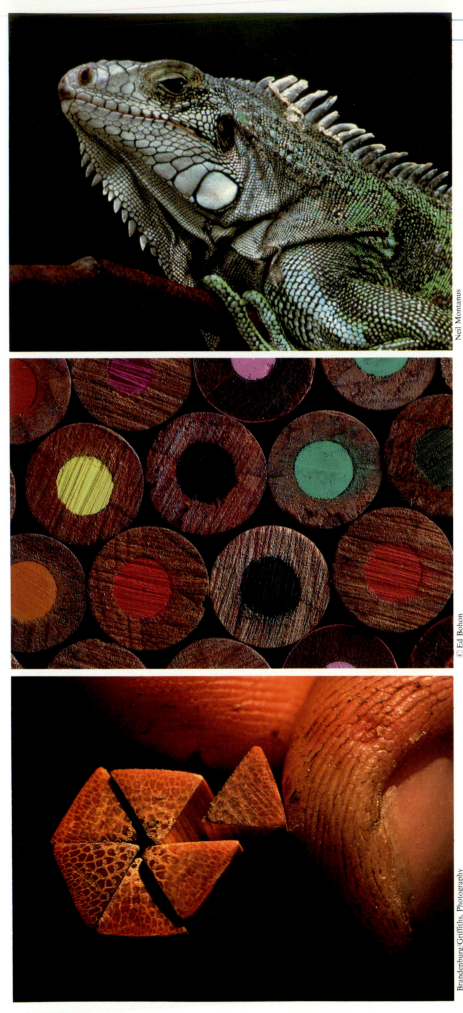

Neil Montanus

Examine the detail of the scales of this green iguana through the medium of close-up photography. Photographed in the Amazon jungle of Peru in bright sunlight with a 400 mm lens and an extension tube. Format: 35 mm. Exposure: 1/60 sec at f/8.

Close-up pictures of familiar objects, such as these colored pencils, gives a sense of magnification. Exposed with a 55 mm MICRO-NIKKOR lens. The pencils were held together by a rubber band and placed next to a north window. A small, white cardboard reflector provided some fill light. The camera was on a tripod and the self-timer, which raises the mirror before exposure, was utilized. The exposure was 1/30 sec at f/8.

© Ed Bohon

Assembling a split-bamboo fishing rod. This graphic information is only available through close-up photography. This photograph was made on assignment for a National Geographic Magazine story on bamboo with a 55 mm MICRO-NIKKOR lens at 1/15 sec at f/22. The warm color results from a tungsten light reflected by an umbrella.

Brandenburg/Griffiths, Photography

CLOSE-UP COMPROMISES

Close-up photographic technique is, at best, a balancing act. The subject matter is so close to the camera lens that each of the standard steps in photography must be carried out with greater care and attention.

Basically, we take close-up photographs to get the following:

- The most exquisite detail.
- The sense of magnification.
- The information not available in other forms of investigation.

To achieve these, we must consider the following interrelated problems.

- The greater the magnification, the more reduced the depth of field.
- The available depth of field requires medium to small lens apertures.
- The medium to small apertures, such as $f/8$, $f/11$, and $f/16$ require longer exposure times.
- The best available depth of field and resolution requires a heightened appearance of contrast.

Film emulsions and lighting techniques must be relied upon to get around some of these optical limitations and obtain the best results.

Viewfinder Technique for Determining Image Ratio.

Magnification

The concept of magnification is related to reproduction or image ratio. Reproduction ratio is the numerical relationship between the dimension or size of an object and the dimension or size of its image. This ratio is shown as two quantities or measurements, usually whole numbers and decimals on either side of a colon. The ratio is always represented with the image "i" on the left side of the ratio and the object "o" on the right, thus i ratio to o or "i:o." (Therefore the ratio 1:2 indicates a magnification of one-half the life-size of the object; the ratio 2:1, a magnification of 2 times the life-size of the object.) To look at it another way, the *i* is the dimension

of the image on the film and the *o* is the same dimension of the object. The ratio can be stated as a whole number such as 1, as a fraction such as 1/4, or as a decimal such as 0.25. It is the decimal form followed by the symbol " × " standing for "times" or "multiplication" which is termed "the magnification."

Let us consider a few examples. If we consider only the standard 35 mm format, it is 24 mm high and 36 mm long. The standard 35 mm SLR camera with the normal 50 mm lens focused at its closest setting will yield an image-to-object ratio of 1:10; that is, it will provide an image one-tenth (1/10) the size of the object. The image, in this case, is reduced by the

lens. There is a fractional magnification, so that the ratio is less than 1; in this case, it is 0.10 × magnification. In such a situation, the distance from the film plane to the center point of the lens is considerably less than from the center point of the lens to the object. This is what we termed medium range close-up or close-focus photography. However, when the lens is extended until the two distances, from the object to the lens and from film to lens, are equal, a 1:1 ratio will result. Anything in the prime focus of the lens will be reproduced on the film exactly life-size. This means that all of the features, edges, lengths, surface projections and holes will appear life-size also.

The simplest way to calculate the image ratio is to measure the object and its image on the focusing screen of the camera. (It is best to use a metric rule, as the inch with its fractions is harder to calculate. A small metric ruler can be installed on the bottom of the focusing screen, or the screen itself can be scribed with measurements.) Once the dimension or detail has been measured on the screen, the number is divided by the actual dimension or detail of the object. The formula for finding the magnification is:

$$m = \frac{i}{o}$$

where m = magnification on the film,
i = image size,
o = object size.

As an example, the object is let us say, 7.2 mm long and it is positioned and the camera arranged so that it fills the 35 mm frame (24 x 36 mm) from side to side. Thus, the ratio is 36:7.2 (36/7.2) and to find the magnification, we divide:

$$m = \frac{36}{7.2} = 5.0;$$ thus the magnification "m" equals 5×.

If we take a more difficult example; let us consider a single feature of an object that we desire to photograph using close-up techniques. The feature we wish to photograph is round and 3.8 mm in diameter and its image half-fills the frame from top to bottom, so that its image measures 12.2 mm in the frame which is 24 mm in height. Again, resorting to the formula,

$$m = \frac{i}{o}: \quad m = \frac{12.2}{3.8} = 3.21.$$

Rounding off the last decimal place, the magnification "m" equals 3.2×.

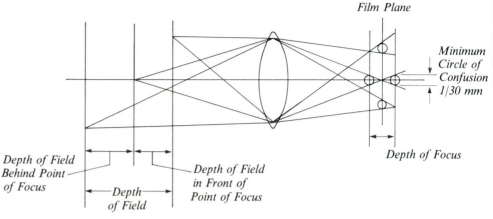

Depth of Field—Optical Diagram.

Depth of Field

The *depth of field* is the range from the nearest part of the object which is in focus to the farthest part of the object which is in focus. The equation for calculating depth of field is:

$$d = \frac{2fc\,(m\,+\,1)}{m^2}$$

where d = depth of field
m = magnification
f = aperture
c = the circle of confusion.

The term "circle of confusion" requires some explanation. The most perfect lens transmits a perfect point of light only imperfectly as a tiny blur. This circle of confusion can be reduced, but never to the same size as the original point. For this reason, a tolerable dimension for the circle of confusion is chosen that will allow sufficient detail for the purposes of the final photograph. Obviously, the acceptable diameter of the circle for a highly detailed transparency of an electronic circuit would be far more critical than that for a billboard-size illustration of a pizza pie. Various manufacturers and authorities have selected 0.10 mm, 0.05 mm, and 0.033 mm as the acceptable diameter of the circle. We will calculate with the 0.033 figure as it works for even the most critical applications.

Let us take an example and calculate the depth of field for a camera set up where the aperture is $f/11$ and the circle of confusion is 0.033 mm, with a magnification of 4×.

$$d = \frac{2 \times 11 \times 0.033\,(4+1)}{4^2} =$$

$$\frac{22 \times 0.033 \times 5}{16} = \frac{3.63}{16} = 0.227 \text{ mm.}$$

It is instantly obvious that close-up photographs of 4× magnification have a very, very shallow depth of field. Fortunately, calculations like this one do not have to be done. There are many, many tables and nomographs like the ones in the back of this book (a depth of field of table appears on page 90) that give the necessary data for good close-up depth of field. In standard photography, usually the depth of field is about one-third in front of the plane of critical focus and about two-thirds behind the plane of critical focus. In close-up photography (especially at 1:1), the depth of field is about evenly divided in front and behind the plane of critical focus. The proper handling of the very shallow depth of field available in close-up situations is one of the most important of all the techniques in the application.

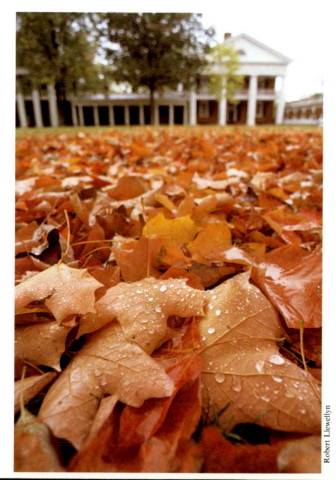

In standard photography, usually the depth of field is about one-third in front of the plane of critical focus and about two-thirds behind the plane of critical focus. This photo of the lawn at the University of Virginia was taken with a 24 mm lens at f/16 on KODACHROME 25 Film as the photographer lay in the wet leaves.

Robert Llewellyn

The Lens-to-Film Distance = "V."

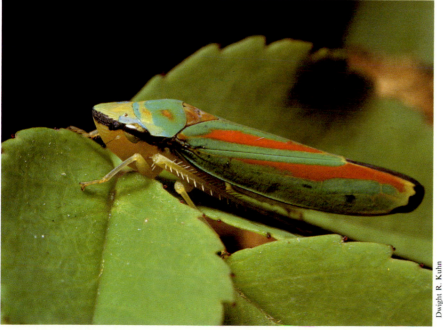

Dwight R. Kuhn

In close-up photography, especially at 1:1 magnifications, the depth of field is about evenly divided in front of and behind the plane of critical focus. A scarlet and green leafhopper on rose leaves was captured with a 55 mm MICRO-NIKKOR lens, reverse-mounted, at 1/80 sec and f/16. A single flash was positioned above and 6 inches from the subject.

Exposure Increase Factor

The closer a camera approaches the object to be photographed, the greater the lens-to-film distance must become. Focusing from infinity down to about 60 cm (approximately 24 inches), the slight extension of the lens as it is moved in the mount to focus is not enough to change the aperture or marked f-stops significantly. However, as the lens is further extended from the film plane, the marked f-stops are no longer correct and a whole set of new exposure determinations must be made based on effective rather than marked aperture. The exposure increase factor must be calculated to take into account the fact that the effective aperture is smaller than the

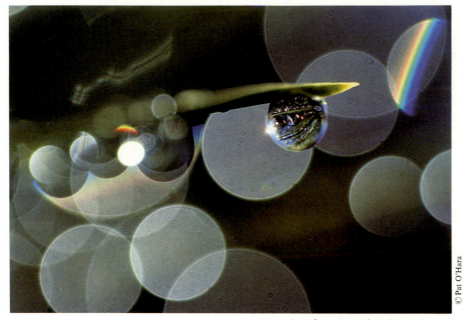

Circles of confusion change size depending upon the depth of field and resulting out-of-focus specular reflections. Here, rain droplets on Ponderosa Pine Needles reflect, or transmit, multiple-sized blurs. Note, also, the diffraction patterns (rainbows) on the edges of some of the blur circles. Exposed with a 100 mm macro lens and a 50 mm extension tube at 1/250 sec at f/4 on KODACHROME 64 Film with strong backlighting.

© Pat O'Hara

marked aperture. There are two common formulae for calculating this value for any single magnification and focal length. The first is:

$$EIF = (m + 1)^2$$

where EIF = the exposure increase factor,
m = magnification.

For example, for an image ratio of 1:10 in which m is equal to $0.10\times$, EIF = $(0.10 + 1)$ multiplied by itself or EIF = $1.10 \times 1.10 = 1.21$. This is too small an increase to be concerned about. But if we take as another example a case where the image ratio is life-size or 1:1, then EIF = $(1 + 1)^2 = 4$.

This means that to accommodate the exposure increase factor, either a larger aperture must be chosen, the length of time of the exposure increased, or a film with a higher speed must be chosen. (Note: Not all of these have to be changed, only one factor — aperture, shutter speed or film speed — will do.) It is clear that changing the aperture opening may not be practical; suppose the aperture is already f/5.6 and the widest opening is only f/4.5! It is always better to extend the shutter speed if that is possible. The situation can become even more acute in the case where an even greater magnification (m) is involved. If we take the example of an m = 10, we discover EIF = $(10 + 1)^2 = 11^2$ or 121! Such a multiplication of the shutter speed would make it a long time exposure. We will come back to EIF later.

(See page 90 for a table of exposure increases factors and aperture compensation.)

The other formula for Exposure Increase Factor is very similar; however, it does not require calculating the magnification first. If you have a small hand calculator, it is very easy to compute. The formula is:

$$EIF = \frac{V^2}{F^2}$$

where EIF = the exposure increase factor,
V = the distance from the approximate position, as near as you can judge, of the lens diaphragm back to the film plane,
F = focal length of the lens at infinity (usually marked in mm).

If we take an example for a 50 mm lens as would be used on a 35 mm SLR camera and find that the distance between the diaphragm of the lens and the film plane is 85 mm, then EIF = $\frac{85^2}{50^2}$ = $\frac{7,225}{2,500}$ = 2.890. For our purposes, this is close enough to 3 to use that as our EIF. The shutter speed would be multiplied by factor of 3. (See page 91 for a table of f-stops to film-plane distances.)

Diffraction

When light rays pass the edge of an opaque object, the rays are bent off course, producing bands of light and and dark, or rainbow-colored light. In close-up photography, such diffraction effects become more noticeable, the smaller the diaphragm opening. With great close-ups the diffraction effects around the edges of the diaphragm actually reduce the sharpness of the image. In an extreme case, a lens on a double extension bellows may be set at f/4 but actually be operating at f/256—a mere pinhole. This tiny aperture will not increase the depth of field greatly, but will actually destroy the sharpness of the image. For this reason, most macrolenses actually work better not at

© Pat O'Hara

Here, the circles of confusion are within visual acceptance because all of the dew drops and spider webs are in the critical plane of focus. Exposed with a 100 mm macro lens at 1/2 sec at f/5.6 on KODACHROME 25 *Film with light from an overcast sky.*

This is a rather standard photo of a fairly flat object, the trunk of a tree. In a black-and-white print, there would be very little difference in tonality, but with color transparency film, there are many tones in the gnarled old bark and pale greens and yellows in the magnificent growth of lichen.

their minimum aperture, which may be $f/32$, but a medium opening of $f/8$ or even $f/5.6$ which, in operation with additional extension, can be $f/16$! It is because of diffraction effects that most small-film-format cameras do not stop down to $f/22$ or beyond. The designers quite wisely realized that the increase in depth of field would be at the expense of the image sharpness.

Resolution

Resolution is the capacity of the lens and film to record fine detail. Since close-ups usually involve fine detail, the concept of resolution is very important. It is just a fact of photographic life that the faster the speed of a given film, the less resolution it provides. While there are many instances when a film of ISO 400, 800, or even 1600 must be used, such high-speed films yield lower-quality close-ups than slow speed films.

Wm. White

29

Generally, the resolving power of lenses is given in lines per millimetre. This often appears in popular photographic publications. With a typical 50 mm lens for a 35 mm SLR, the value is 40 or more lines/mm. While there is a certain degree of truth in rating lenses this way, this is certainly not the whole story. Most lenses are designed to yield the best resolution through the center rather than toward the edges where there is more curvature to the glass. For this reason, you should place the area where finest detail is desired in the center of the photograph.

Special-purpose macro lenses have better resolution than the larger-aperture "normal" lenses at close distances. The larger the aperture a lens has, generally the lower the overall resolution. For this reason, the diffraction effects and the extension effects which produce the EIF (exposure increase factor) cannot be defeated by starting off with a giant aperture. The best quality macro lenses and high resolution lenses suitable for close-ups typically have apertures of $f/3.5$, $f/4$, or smaller.

Image Quality

The quality of the final photographic image, whether it is a color transparency, a color print, or a black-and-white enlargement, is really rather subjective. It depends, first of all, on the degree of detail which we want to be able to see in the photograph, the detail of the original, and the acuity of our eyesight as individuals. Generally, the finest structures are edges, fine lines, and what are called point lights or specular reflections. These point lights are the smallest reflection points in the photograph. They are the one feature most subject to the "circle of confusion" effects mentioned earlier. These effects in the final transparency or print are often termed "blur circles." They are de-

Robert E. Mayer

Another photograph with low-contrast ratio. Without color to differentiate between red and green, this forest leaf would present a drab scene. Exposed with a MAMIYA SEKOR D5X-100 Camera with a 60 mm macro lens focused at 1:1. The handheld exposure was 1/125 sec at f/8 on KODACHROME 64 Film.

pendent upon the size and viewing distance of the final image. For example, if the print dimensions are 11 x 14 inches and it is viewed from a distance of, let us say, 5 feet, a blur circle may be substantially larger than the 0.033 mm allowed for transparencies. The problem is always that resolution and depth of field are related and one, or both, must be compromised to gain the best and most acceptable image quality.

One principle is true in most cases; that the initial magnification should be gained in the original close-up photograph and not achieved by oversize enlargement either by projection or in the darkroom. Attempts at such double or triple magnification rarely work with standard films and optics.

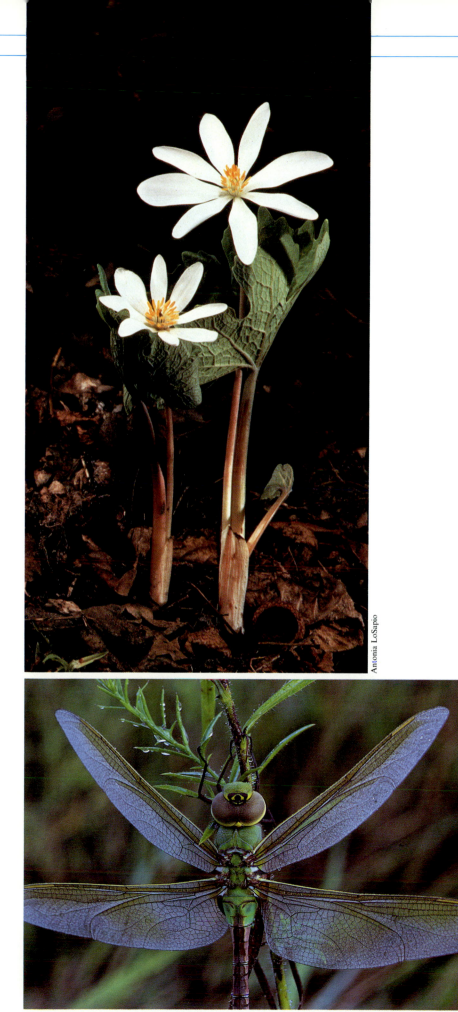

Here is a truly successful attempt to increase contrast in close-up photography by using electronic flash to spotlight the subject. These flowers of the bloodroot plant were photographed with a 35 mm SLR and 55 mm macro lens. Because of the whiteness of the flowers, the exposure was from 1 to 2 stops less than normal.

Contrast

While the human eye is capable of detecting an enormous difference in degrees of lightness and darkness in a scene, the camera is not. It is a characteristic of all optical systems that the contrast of the image decreases as the magnification increases. Unfortunately, as the contrast decreases, the resolution decreases as well. It takes a very thorough knowledge of the techniques of close-up photography to retain the highest possible magnification and resolution of details while achieving useful contrast. Generally, a ratio is used to express the difference between the lightest and the darkest elements in a scene. For example, here are some of the most common contrast ratios:

Distant landscape	1:20
Portrait of a blond	1:20
Normal landscape	1:30
Portrait of a brunette	1:100
A photo against the light	1:250
Interior with beams of sunlight	1:1000

When the camera-to-subject distance is shortened, the ratio of contrast becomes very much reduced and steps must be taken to add contrast by various means. Interestingly enough, while there are only about eight stops of gray between black-and-white in photographic prints, there are vastly more in a color transparency; actually a ratio of 1:1000 is possible.

Low-contrast does not necessarily mean poor quality. This monochromatic dewy green dragonfly is lovely. The exposure time was only 1/4 sec. Using a tripod and locking up the camera's mirror contributed to the sharpness.

Antonia LoSapio

© John Gerlach

Close-focus field photography with large-format cameras

A Personal Account by Dennis Brokaw

I find close-ups an especially important and rewarding aspect of my landscape photography. Not only may a small part of a scene symbolize the whole, but a limitless universe of subjects and compositional forms lie within an arm's reach of the camera lens.

"Photographing more-or-less recognizable subjects, large enough to be part of everybody's everyday visual vocabulary, is pretty easy with most cameras."

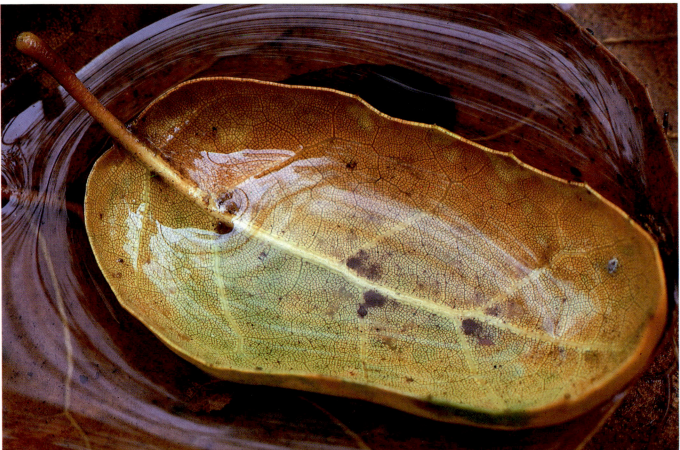

Dennis Brokaw

Often, when visual clutter and distractions preclude getting a clean, taut overall view of an area, near-at-hand details or small parts of the scene can still be organized into meaningful and satisfying substitutes for the greater scene. In following this approach, it is usually fitting to strive for the overall everything-sharp sort of treatment that I try to achieve in an ordinary scenic image. Since I am there trying to photograph more-or-less recognizable subjects, and they are usually large enough to be part of everybody's everyday visual vocabulary—i.e., they are either larger than a breadbox or not appreciably smaller than one slice—they reside in the outer, more comfortable suburbs of the close-up world, the area of close-focus photography—from 1:10 to 1:2 or so. This is a part of the close-up world that is pretty easy to negotiate with most cameras, although it does demand a disciplined technique.

Moving still closer, into the more difficult region between 1:2 and 1:1, or even beyond 1:1 where the image on film is larger than life size, you leave behind the visually familiar world as well as the very possibility of rendering everything in sharp detail. You leave the "detail of a scene" and enter a usually unseen, unnoticed space of subjects, compositions and topographies that will stand on their own merit only when realized by the camera. Fortunately, as there are fewer ways to get everything sharp in depth, so too are there fewer known visual references. To some point it all averages out and the imagery succeeds as "landscapes." However, the closer and closer you look and photograph, the harder and harder grows the photography of these mini-universes, until finally, at several times magnification, you find that all you can even hope to capture in sharp focus is a thin central band of the bee's eye, and that only at an effective lens

Dennis Brokaw

Cropping out the clutter of a shoreline and selecting a patterned composition of reeds made a stark photo with natural backlighting. Taken with a 35 mm SLR, a 400 mm lens focused close, on KODACHROME 64 *Film.*

Limpets and Sandstone: A Pacific scene captured on 4 x 5 KODAK EKTACHROME 64 Professional Film.

Dennis Brokaw

almost-as-spontaneous probing with a handheld SLR rigged with a flash setup (especially a ringlight) using small apertures and macro lenses.

Each approach has its charms as well as its limitations. Since I use a 4 x 5 view camera and natural light for my landscapes and like the freedom that comes from simplicity and a minimum of fussy equipment, I also use the 4 x 5 for most of my close-ups, whether of the very sharp part-of-a-scene, recognizable-subject variety or the much closer "purely photographic image" that has no counterpart in normal visual experience. Here, then, is how I work with my minimal equipment, and here are the solutions I've worked out for the various problems encountered in close-up photography afield.

The object of my field photography is the spontaneous exploration and enjoyment of nature. I rarely photograph much closer than 1:1, and virtually never closer than 2:1 (2× magnification). Even at 1:1 the physical difficulties of subject movement and camera positioning become vexing in a hurry. In this regard it is important to bear in mind that it is quite easy for almost any camera system to get down to 1:2 with a minimum of fuss, 1:1 with a bit more of a struggle, and magnifications greater than 1:1 only with rapidly increasing difficulty. Since 1:1 with an 8 x 10-inch camera means a subject size 8 inches by 10 inches, and 1:1 with a 35 mm camera means a subject size one inch by one and one-half inches—it follows that it's possible to make life a lot easier simply by picking a film format appropriate to the size of subjects needed to be photographed afield. A subject 2 inches by 3 inches is a piece of cake with 35 mm, a bit taxing with 2¼, quite difficult with 4 x 5 and a

stop of *f*/72—with its inherent diffraction losses that limit resolution—letting the leaf the insect is on, the rest of its body and the vista behind it merge into one glorious, amorphous, impressionistic blur. That sort of picture is, of course, a long way from depicting the landscape in full detail, clarity and depth. Clearly, then, there must be some dividing line between landscape photography and laboratory photography. For me it's around 1:1.

View camera photography inevitably entails many steps that must be carried out in checklist fashion—from positioning the camera and tripod, composing and levelling, focussing and making both geometric and sharpness-in-depth swing-and-tilt adjustments, to the calculations of exposure, including filter factors and reci-

procity-failure compensations. To this gamut, I quickly found, had to be added the special problems of close-up photography; subject movement, camera vibration, bellows-draw factor determination, lens sharpness, diffraction limits, tripod convenience, and film reciprocity problems with virtually every exposure.

So great are the technical difficulties of close-up camera work that there is a natural tendency among photographers I know, that once one successful approach has been found, to stick with it forever. Surely the 35 mm SLR, wide-aperture, wet-belly approach is intoxicating in the endless kaleidoscopic variety of compositions that are everywhere; shooting handheld at *f*/2.8 at 1:1. It's great lighthearted fun. Too, marvelously detailed close-ups can be had by the

Temporarily stranded in a tidal pool, this red starfish contrasts nicely against the cool colors of rock and shellfish. On 4 x 5 KODAK EKTACHROME 64 Professional Film.

Dennis Brokaw

hairy beast with 8 x 10! As far as ease-of-use goes, the smaller cameras have all the best of it. But as regards absolute information and enlargeability, the bigger the film the better. In a practical sense, this is only partly true (and not considering the superb sharpness of KODACHROME Film) as in the very, very close world there are no built-in mental standards of definition, no memory of other scenes and images ready to spring to the mind's eye as they would with landscapes.

At times I'll switch to 35 mm for photographing very small subjects just because it's a lot easier and I have no specific need for larger film. Any loss of printing sharpness due to the smaller film would become apparent only when side-by-side comparisons to large-format images of the same subject, enlarged to the same final

size, are available (or when any original is enlarged enough for film grain to be objectionable). In any case, no matter what format is used, the problems of close-up work remain the same. It's just that they set in a bit later with small formats, a bit sooner with large.

THE TRIPOD

A tripod is absolutely essential in natural-light close-up work, and its ease-of-use bears directly on the quality of the photographs that result. Undoubtedly the first requirement is stability. Make certain the tripod you choose can support the weight of your camera and heaviest lens. It should not appear unbalanced or out of proportion. Great flexibility is the second consideration, the ability to position the camera almost anywhere

you could handhold it, quickly, securely, and easily. This means high or low — very low — virtually on the ground. To be more effective, a close-up tripod should also have legs that will splay out virtually flat and lock in that position. The legs should also move independently of one another, giving the photographer greater flexibility to position the tripod in cramped spaces or on unlevel terrain. Any tripod with a vertical center column is useless. Vertical center columns can only interfere with getting down to the ground, or place the camera at the end of a long, wobbly stalk — two very undesirable features in close-up work. For smaller format cameras, a tripod with a monorail-style center column offers more flexible camera placement. The weight of large format cameras can preclude extending the camera horizontally on a monorail-style center column. Instead, use a tripod with no center column or don't extend the center column for the greatest stability.

THE TRIPOD HEAD

While any secure tripod head will indeed hold up a camera, some are a lot easier to use than others. Heading the list are the larger, stronger, full-movement ball-and-socket models. I prefer either the largest LEITZ (which is sturdy enough to hold a light 4 x 5-camera) or the larger LINHOF versions (the largest of which could hold up a small car). Since levelling the tripod itself may be impossible in the field, even the best 2-way pan/tilt heads may often lead to a vexing "you can't get there from here" feeling when working close. In fact, it may even be easier to use a pan/single-tilt head than a 2-way! Ball heads are the best.

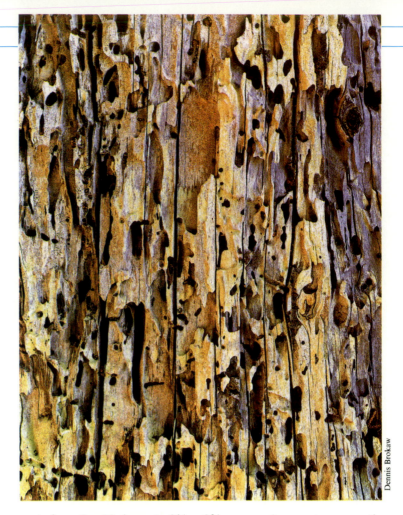

Worm-Eaten Cypress Bark: Photographed with a 4 x 5-inch LINHOF TECHNIKA Camera, a 150 mm SYMMAR Lens, and KODAK EKTACHROME 64 Professional Film. Exposure: 1 second at f/32 with a CC 20 blue filter for reciprocity color correction. Ratio: 1:1. Calculations: Reading minus 2 stops for bellows extension, minus 3/4 stop for film reciprocity, and filtration. Reproduced from an 8 x 10 dye transfer print made by the photographer.

Dennis Brokaw

THE CAMERA

Since I use a folding 4 x 5 LINHOF TECHNIKA Camera for my landscapes, I also use it for my close-ups. I recognize that many photographers cannot get accustomed to using a folding camera for close-ups because they provide front-focussing only. When front focussing you also change the lens-to-subject distance, and thus the magnification. The closer you get the more you have to reposition the camera each time you focus in order to maintain a chosen image size. I gauge fairly accurately where to place the camera by a seat-of-the-pants intuition borne of many years of experience and misadventure. And I'm unwilling to give up the light weight, portability and convenience of using the single folding TECHNIKA Camera for everything.

Certainly the easiest large-format camera type to use for close-up work anywhere is a monorail view camera offering both front and rear standard focussing. It is even better if it also offers some way to move the entire rail toward, or away from the subject without moving the tripod. And ideally, if it also allows some degree of rotation of the rail within a locking central tripod attachment there would be very little in the way of camera positioning that couldn't be done easily. Full movements of both front and rear standards, swings, tilts, rises and falls, complete the description of the perfect close-up camera. And fortunately there are a good many to choose from, new and used, in for-

mats from 8 x 10 down to 2¼ x 2¾.

In the medium format, one is very much at the mercy of the makers of particular systems. Hasselblad offers flash synchronization at any speed, very gentle vibrationless shutters (with the mirror locked up), the possibility of through-the-lens metering and fine lenses suitable down to 1:1. The ROLLEI SL66 Camera offers similar lenses, a built-in bellows, mirror lockup (which is always essential in close-up work), some degree of lens tilt and the possibility of adapting any non-standard special lens/shutter combination. Other systems vary in usefulness.

Among the numerous fine 35 mm cameras are an overwhelming variety of special close-up lenses, automatic accessories, through-the-lens metering systems and, of course, that smaller film size that makes getting close to small subjects very much easier. However, there are only so many things you can do with postage-stamp-size film and large, grainless enlargements aren't among them. The same techniques that wring every scrap of definition out of that tiny original also

wring out every tiny grain and scratch.

I will always prefer large film for most work. There is a sort of marvelous clarity that comes from a no more than two-, or three-times enlargement of a color original that in a certain sense "removes photography from the photograph" and leaves one more in direct contact with the original subject, in all of its seemingly infinite detail and clarity. Razor-sharp edges with no hint of film grain, brilliant color, and subtle tonal gradations are all a flat-out sensual delight, and for me worth the extra struggle with big cameras.

THE LENS

Nowadays we are all doubly blessed, optically. Not only is there a wide array of special purpose lenses available for all formats, but even the "ordinary" or "standard" lenses are often perfectly suitable for work down to 1:1 — and if turned around and mounted reversed they produce for magnifications much greater that 1:1! But generally we opt for one of two possibilities: either we use a special

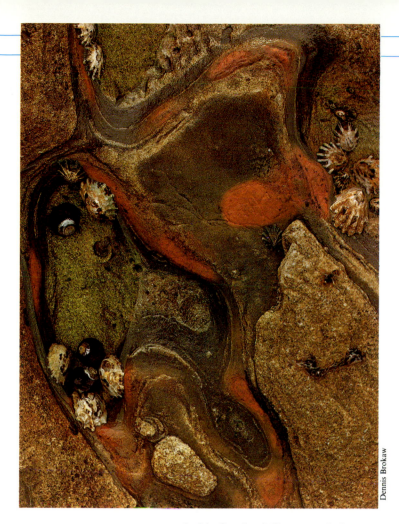

Limpets and Turban Snails on Sandstone: A beautiful shallow tide-pool composition taken with a 4 x 5 camera, 150 mm lens, and KODAK EKTACHROME Professional Film. A KODAK WRATTEN No. 85B Filter was used, as well. Ratio is 1:1.2. Calculations: Minus 1 2/3 stops for the 11-inch bellows extension, minus 1/3 stop for film reciprocity and minus 2/3 stop for the 85B conversion filter. Reproduced from an 8 x 10 dye transfer print.

Dennis Brokaw

close-up lens in addition to a normal lens, or we use a single lens that performs adequately over the full range in which we intend to photograph. The latter is not at all impractical. For example, a close-up lens for the 4 x 5 such as a RED DOT ARTAR, that according to the manufacturer may be optimized for 1:10 or so, will also make beautiful images at 1:1 at most any aperture, as well as at infinity at $f/22$. Except for aerial photography that demands sharpness at a very wide aperture, that sort of performance would be adequate for probably 90 percent or more of all view-camera subjects. After all, no one with a 4 x 5 is going to shoot a landscape at $f/11$ and expect front-to-back sharpness. The necessity of using the near-distance-corrected lens at $f/22$ or smaller aperture to cover up its poorer correction at long distances is more than masked by the necessity to shoot *any* subject requiring sharpness in depth at very small apertures.

Conversely, most of the top grade symmetrical, six-element view camera lenses such as SYMMARS, NIKKORS, SIROUARS, and the like are *equally* suitable for the full range of photography from infinity to 1:1. They are optimized for use at longer distances, it is true, and they do generally allow you to make sharp images corner-to-corner at $f/11$ (instead of at $f/22$ as is the case with process lenses) when the subject permits (infrequently), but when stopped down to any likely-to-be-needed aperture in close-up work —$f/16$ to $f/32$—the images they yield are practically indistinguishable from those made with any special close-up lens. There *are* differences in image quality when using any lens outside its design range and comparing the results side-by-side to one used within its design range, but the differences almost always vanish in a two- or three-times' enlargement.

The key to using a single lens for all work is simple enough: use a quality *symmetrical* lens. There are slight variations from true symmetry in all lenses except those few process or copy lenses that are strictly optimized for 1:1. They are the same frontwards or backwards, and are generally the least suitable "process" types for longer range work. Process or apo-chromatic lenses generally sport small maximum apertures—$f/9$ or $f/10$—which, in the near-normal focal lengths, can often be too dim to see through for clear focussing. I use both process and normal wide-field symmetrical lenses for close-up work. A transparency made with my $8^{1}/_{2}$-inch SYMMAR-S Lens at 1:1 and $f/16$ cannot be distinguished from an identical image made with my $8^{1}/_{4}$-inch RED DOT ARTAR Lens at 1:1 and $f/16$—unless you take a very high-power magnifier to the very corners of the image. No one could tell the difference in an 8 x 10 print. Making a comparison the other way, that is comparing an ordinary landscape image made at $f/22$ with the $8^{1}/_{4}$-inch SYMMAR-S Lens with an identical image made with the $8^{1}/_{4}$-inch ARTAR Lens at $f/22$ will show similarly slight differences. The normal wide-field SYMMAR-S Lens will show definitely better contrast and perhaps a bit better definition. Even so, when prints—even very large prints—are made, those differences will probably vanish. It's a happy dilemma: heads you get acceptable imagery; tails you get acceptable imagery. One lens is easier to see through than the other for focussing, the other is lighter to carry. No matter whether you use a SYMMAR, SYMMAR-S, GOLDEN DAGOR, SIRONAR, NIKKOR, ARTAR, REPRO-CLARON, FUJINON-W, APO-RONAR Lens, or even a shutter-mounted enlarging lens such as a

COMPONON you will be well served; able to make fine printable images at virtually any magnification!

The lenses that aren't suitable for close-up work tend to be those that are of unsymmetrical design—all retrofocus wide-angles and telephotos—and those few symmetrical lenses whose nodal points are a long way from the middle of the lens—SUPER ANGULONS, for example. Too, both retrofocus and telephoto designs, as well as most high-speed wide-aperture lenses have pupillary magnifications other than 1. Pupillary magnification is the ratio of the visual (optical) size of a lens aperture when viewed from the front and then the rear. Retrofocus wide-angles have apertures that appear small from the front, large from the rear. Telephoto designs are just the reverse. High-speed normal lenses, such as the very sharp 80 mm $f/2.8$ ZEISS PLANAR Lens used on HASSELBLAD and ROLLEI SL66 Cameras are unsymmetrical, have pupillary magnifications greater than 1, and fall off noticeably in sharpness at very close distances. The special close-up lenses such as the S-PLANARS offered by Zeiss are both more symmetrical and have pupillary magnifications close to 1.

Any lens with a pupillary magnification other than 1 virtually demands through-the-lens metering capability in order to determine exposure. Close-up exposure increases for symmetrical lenses with pupillary magnifications of about 1 are extremely easy to determine by using a method I shall detail below. It's a major point when using a view camera, so the selection of a high-quality, symmetrical lens with a pupillary magnification of 1 is virtually essential. True, lens manufacturers today are designing many "floating element" lenses to extend high performance over a wide range, but even the very best of these give up a bit of performance in comparison

with true macro designs, and they are available only on small-or medium-format cameras, anyway.

One other important consideration in a close-up lens is focal length. Any lens much removed from what is 'normal' for the format gets rapidly out of hand for close-up work. This is due to the inescapable reality that to obtain 1:1 reproduction any lens must be racked out to *twice* its nominal focal length. Most 4 x 5s offer 12 inches of bellows which would allow 1:1 with a 6-inch lens, some offer 16 inches of bellows which would allow 1:1 with an 8-inch lens, and almost none offer 19 inches of bellows which would be necessary to reach 1:1 with a 9½-inch lens. These longer extensions make the whole system more vibration-prone in outdoor breezes. The 6- and 8-inch lenses are easily the most useful on 4 x 5; the 12- and 16-inch lenses on 8 x 10; the 8-, 10- and 12-inch lenses on 5 x 7. Furthermore, for ease of close-up bellows factor computation, the 4, 6, 8, 10 and so on—i.e., even-number-of-inch focal length lenses are the best when using the simple system that follows below. Lenses shorter than normal have a limited usefulness in close-ups, since even at 1:1 you can find yourself maneuvering the camera awkwardly close to the subject. However, if you need to photograph subjects at greater than 1:1, say 2:1 or 3:1 magnification, then they make a lot of sense. They can be more-or-less preset to the desired magnification and the entire camera moved back and forth for focussing. Lenses for this use should be short lenses optimized for 1:1—and there are very few currently available. Six-inch APO-RONAR Lenses are still available new; 4-inch ARTAR Lenses are only on the used market.

Finally, going much beyond 3:1 magnification brings up the possibility of using a short but normal or macro lens designed for general photography *mounted in the reverse position*.

After all, a lens suitable for 1:10 image-to-object reduction is just as suitable for a 10:1 image-to-object magnification! For special, very high magnifications (these are virtually all studio subjects, lit with electronic flash) I use an ordinary NIKON MICRO-NIKKOR Lens on the 4 x 5, at marked apertures of $f/5.6$ or $f/8$, with the lens mounted in the reverse position. (The *effective* apertures become *very* tiny as magnifications are increased, and diffraction losses at $f/64$ in a close-up are just as bad as diffraction losses at $f/64$ in a landscape!)

THE SHUTTER

Anyone who has ever stood on his or her ear outdoors, fumbling around the front of a precariously balanced view camera, trying to see and set the f-stop without tipping over the tripod, collapsing a lot of the subject, or doing permanent spinal injury will be readily able to appreciate a couple of minor mechanical inventions now available. One is the aperture pre-selector marketed by Linhof and Sinar. The other is the click-stop detent (eg. COMPUR) Shutter. With the first, you can set everything from behind the camera. With the second, apertures are indicated by one-third or one-half click detents. You can simply close your eyes and count down to a desired aperture without having to clamber around or under the camera. A *great* boon to close-up work afield with view cameras! Any lens mounted in a shutter that can't be run blind, by feel alone, is to be used with the foreknowledge that sooner or later it will drive its owner to fits of rage and apoplexy, not to mention costing a lot of good images.

THE AIR RELEASE

One omnipresent source of unsharp close-up images is vibration. There is little or nothing to be done about subject motion—flowers and grass moving in the breeze—other than to wait for still air. But there is plenty to be

Dennis Brokaw

Dennis Brokaw

Abalone Shell Fragment and Kelp Pods in a Tide Pool: Another shallow-water composition. Ratio is 1:1. Equipment included a 4 x 5-inch LINHOF TECHNIKA Camera, a 150 mm SYMMAR Lens. KODAK EKTACHROME 64 Professional Film was modified by a CC 30B filter. Exposure calculations: Minus 2 stops for bellows and 1 stop for the filter and film reciprocity. Exposure was 2 sec at f/32.

Kelp Leaves: The beauty of textures and patterns is often enhanced by eliminating color and making sparkling black-and-white photographs. This one is on 4 x 5-inch KODAK PLUS-X PAN Professional Film shot with a LINHOF TECHNIKA Camera, a 150 mm SYMMAR S Lens at 1/15 sec, f/22. Bellows measured 8" (about a ratio of 1:3) and the calculated reading was less 2/3 of a stop from the meter reading.

done about flimsy tripods, shaky cameras, and that eternal nemesis, the cable release. When a camera is racked out to 1:1, it grows appallingly sensitive to the tiniest tremors which, at the long exposure times close-ups usually require under natural light, have ample opportunity to wreak havoc with images formed by even the finest lenses. There are two solutions: the internal self-timer release which is now no longer available on most shutters, and the pneumatic air release, which is available anywhere. Sharp, long-exposure close-ups largely hinge on using an air release for each and every exposure. Otherwise you should resign yourself to soft, streaky and blurred edges. Even the longest mechanical release manages to transmit some vibration to the lens or camera. The air release is cheap, easy, and sure.

VIEW CAMERA MOVEMENTS
It is hard to find any subject in all of photography, save flat copy, that cannot have its apparent sharpness in depth improved by the swings and tilts of the view camera. This is as true

up close as anywhere. And the rises, slides, and such can be a great help to composing and centering an image. After all, it's a lot easier to move bits of the camera—lens standard and film back—around than to try to relocate the entire tripod one-half inch when you are out on some precarious hillside.

APERTURES
I admit to using whatever aperture gives me the sort of image I want. I must concede, however, that *effective* apertures below f/64 net an easily-seen-on-the-transparency loss of clarity. An effective aperture of f/64 is obtained by a 1:1 magnification and a marked lens aperture of f/32, a 1:2 magnificaiton and a marked aperture of f/45, and so on. With the lens set at

a marked f/45, 1:1 magnification will yield an effective f/90 and an ineffective, soft image. With big film like 8 x 10 this is stili an accepted practice when photographing detailed small objects like jewelry, but it works only because the final reproduction is a very low magnification or even a reduction from the transparency. Magnify any f/90-made image and you find mush! This is the nub of one of the rock-and-hard-spot problems in close-up photography; diffraction. We always need lots of depth of field to get a sharp-in-depth image on film, yet stopping down inevitably steals resolution. There is nothing to be done in color. In monochrome you can make exposures through a blue filter which raises the limits of resolution by using only shorter wavelength

Dennis Brokaw

light, but it's not practical very often. (In fact it is exactly this sort of double bind that led to the development of the scanning electron microscope which circumvents these inevitable optical problems associated with the nature of light.) So a good rule of thumb when working in nature is to use all the mechanical aids you possibly can to gain depth—i.e., view camera movements—or minimize the *need* for extended sharpness in depth by choosing easier subjects whose main elements tend to lie in a single plane. Always lying in wait to confound us is the great fact of optics: higher resolution is obtained only through higher apertures while greater depth is obtained only through smaller apertures. I always try to use the widest aperture that will *just barely* get me the depth of field I need. Stopping down beyond that point only costs definition. Estimating this point by observing the groundglass while stopping down is a matter of experience, although often you have to go one or two stops beyond where everything first appears sharp on the groundglass. But go too far . . . and you get ephemeral, pearly, edgeless, hazy, impressionistic glop—images that could actually have been rendered more crisply with better detail (resolution), with a smaller camera!

LIGHTING

Natural light means just that; taking what the world offers. It's just that sometimes it offers better than at other times. Large, hard shadows and strong lighting contrasts are the bane of the close-up photographer more often than not, and the soft, diffuse light of overcast days—before, after, or even during storms—is my first preference. Photography in open skylight, also sometimes presents insuperable color obstacles. No filter seems to make it look like it was a cloudy day. Traces of slightly warm, filtered sunlight set against traces of

Condensation: The beauty of the fog drifting through the forests of the Monterey Peninsula is legendary. It also makes pretty patterns when it condenses on the hood of a car! Exposed with a 135 mm SYMMAR S Lens, a 4 x 5 LINHOF TECHNIKA Camera, KODAK PLUS-X Pan Professional Film at 5 sec, f/16, using artificial light. Calculated exposure was meter reading minus 2 stops for the bellows extension of this 1:1 ratio.

slightly cool, filtered blue skylight are ideal for most subjects. In fact, color photography often hinges on the most subtle balances between "main" and "fill" light occurring in nature. I find often the natural "two-point" light occurs just after a storm has passed, when there are open areas of clear, deep blue sky behind great puffy white clouds. We joke about the flash/umbrella as being a "portable cloud." The natural cloud is better!

Naturally anything that leads to a strong image is fine, whether it's open sky, soft high clouds, direct sunlight, or light reflected from a dozen surfaces. There are no absolute rules, although color films and color reproductions do better with softer lighting contrasts if the object is to hold some detail throughout the tonal image. In black-and-white there is always the option of altering film development to obtain a superbly printable negative, as well as dodging and burning manipulation in printing.

One technique that I use fairly often in my close-up work is "tenting." Not in the usual sense of building a light-diffusing enclosure around the entire subject but rather a selectively masking off of undesired reflections. Anything with reflective or mirror-like surfaces can usually be improved by tenting. The basic maneuver is to take the black focussing cloth and hold it, during light measuring and film exposing, in such a way that it covers the lens' field of view *as seen in the reflection from the subject*. For example, aiming the camera down at a tidepool is an exercise in futility. The surface of the water as well as any objects lying in the water's surface film will reflect the sky and nearby objects—such as the camera, the tripod, the photographer, etc, to the great detriment of color saturation, naturalness, underwater image clarity, and so forth. By placing the tent in the lens' reflected image path, light leaks in from all sides without creating glare, revealing the subject in all its rich color and detail. It's like looking across a lake at a mountain reflected in the lake; the water and things in it are rich and colorful within the

mountain's reflection; overwhelmed and washed out elsewhere. The results of tenting are similar to the use of crossed polarizers in copy work—polarizers over the lights crossed with one on the lens. Suddenly all that rich color and detail is revealed and just leaps out. It's wonderful!

CLOSE-UP EXPOSURE COMPENSATION

It's well known that the effective aperture of any lens begins to decrease whenever it's extended, and that whenever the lens-to-subject distance is less than about eight times the lens' focal length some allowance must be made for the fall-off of light reaching the film. I have devised a simple, foolproof formula for quickly calculating that light fall-off in terms of f-stops—which can easily be added to other information on the dial of any light meter. All you need to know is the focal length of the lens, and the total bellows extension you will be using.

The formula is:

Loss of light (in terms of f-stops) equals the total measured bellows extension minus the lens' focal length times 2 over the lens' focal length.

Expressed mathematically it reads:

$$L = (E\text{-}f) \times \frac{2}{f}$$

Where L = loss of light (in f-stops)
E = bellows extension
f = focal length of lens

To use the formula, you need only make sure the units of measure are consistent. If you use the "inch" focal length of a lens, you also measure bellows extension in inches. Conversely, if you use the millimetre focal length of a lens you must also measure the bellow extension in millimetres. Using the "inch" version of the formula is especially practical for view camera photographers who speak of a 6-inch lens or a 12-inch lens—rather than a

150 mm or a 300 mm lens—and so on. All we need to measure bellows extension is a small tape measure—or even the known distances between our fingers!

Understanding and using the formula is much easier even than might appear at first. What we are doing is measuring the "unnatural" lens extension in close-up work and multiplying it by the lens' natural "fall-off factor." The derivation of that fall-off factor is simple once we realize that *any* lens extended to 1:1 will be extended to twice its focal length at infinity, and that there will always be a two-stop loss of effective aperture. (The only exceptions to this generality are lenses that are greatly asymmetrical or have pupillary magnifications other than 1—and these are almost invariably unsuited for close-ups anyway!) We observe an actual case formula where light loss is a known amount; 1:1 = two f-stops.

Light loss = 2 = (function of extension) x (function of focal length)
2 = (2f - f) x (k/f)

solving for the constant k,

2/k/f = f = 2f/k
kf = 2f therefore k = 2

Which is to say that any lens "fall-off factor" is 2 divided by its focal length.

To take a few examples, suppose we are using a 6-inch (150 mm) lens, focus on a nearby subject, take out our tape measure and find we have a total bellows extension of 10 inches (250 mm). By definition that "6-inch" lens is normally extended 6 inches when focussed at infinity. If we subtract 6 from 10 we find we have 4 inches of "unnatural extension." We determine the lens' inherent fall-off factor (expressed in terms of f-stops per inch of unnatural extension)

by putting 2 over the focal length in inches, or $^2/_6$, which is $^1/_3$ stop per inch. Having 4 inches to account for, we multiply 4 times $^1/_3$, which gives us a calculated light loss of $^4/_3$, or $1^1/_3$ f-stops, at our measured extension. Another way of saying the same thing is that this—or any other—6-inch lens has a rate of light fall-off of one third of a stop for each inch of extension past its infinity setting.

To take another example, if we are using a 12-inch lens and focus on something requiring 18 inches of bellows extension, we are using 6 inches more bellows draw than normal. The 12-inch lens falls off at the rate of $^2/_{12}$—or 1/6—f-stop per inch of unnatural extension. Applying the formula we multiply those 6 inches of extension times the $^1/_6$ f-stop/inch "fall-off factor" for this lens, which yields the information that we have a total light loss of $^6/_6$ or 1—f-stop light loss.

And still another example, if we are using an 8-inch lens, focused on a very small object, magnifying it larger than life size, and find we are using 20 inches of bellows extension, we subtract 8 from 20 (which is 12 inches of unnatural extension) and multiply this times $^2/_8$, or $^1/_4$. Twelve times $^1/_4$ equals 3, which means we are actually getting 3 full f-stops less light onto the film.

Obviously wherever the light loss per inch is expressed by the simple fraction 2/focal length in inches, it's a bit easier to reckon things if you are using lenses of even-numbered inch focal lengths. A 4-inch lens loses $^1/_2$ f-stop per inch; a 6-inch lens loses $^1/_3$ f-stop per inch; an 8-inch lens loses $^1/_4$ f-stop per inch; a 10-inch lens loses $^1/_5$ f-stop per inch—and so on. Our formula works just as well and accurately for odd-numbered focal length lenses, it's just a bit harder to think in terms of $^2/_5$, or $^2/_7$, or $^2/_9$ $^1/_2$ f-stops per inch times so many inches.

For small formats or for lenses of odd focal lengths that do not readily convert to inches (e.g., 60 mm, 135 mm, etc) all that need be changed to apply the formula are the units of measure, from inches to millimetres. The lens "fall-off factor" is then expressed by the fraction 2/focal length in millimetres. To give an example, if we are using a 35 mm lens at a total measured bellows extension of 125 mm, we subtract 35 from 125, leaving us an unnatural extension of 90 mm. This we multiply by $^2/_{35}$, which yields 5.1429 *f*-stops light loss to the film.

(See page 91 for a chart of bellows-extension correction factors.)

LIGHT MEASUREMENT AND EXPOSURE CALCULATION

In most close-up work there is apt to be quite a bit of additional calculation beyond simply measuring light; twisting a light meter's dial and reading off combinations of speed and aperture to see which work best. Small effective apertures, low light, long bellows extensions, filter factors, and film reciprocity failure adjustments must all be accounted for before deciding "that's it" and pushing the button.

I happen to use WESTON Meters, but any meter where light values are expressed in terms of *f*-stops (which correspond to doubling quantities of light) is equally useful. In that way, all the corrections can be converted into fractions of *f*-stops and entered on the dial. To take an example, let us suppose I am photographing some small object at an image: object ratio of 1:2. If I am using an 8-inch lens on my 4 x 5, I will measure a total bellows extension of 12 inches. Using my bellows draw factor I calculate I will lose one full *f*-stop—worth of light. So I first measure the light from (or if I choose, measure incident light reaching) the subject and initially "place" the subject, as I wish to render it, on the film's scale. (By this I mean that if

I am photographing a very dark subject, such as obsidian rocks, I may elect to give less exposure than the meter indicates in order to preserve a dark finished image; conversely, if the subject is a snowbank I will allow one to two more stops exposure than the meter indicates to keep the subject white. By itself the uninterpreted meter will always try to guarantee nice, neutral gray results). After that, I will enter the one-stop's worth of light loss caused by the bellows draw by moving the pointer back down the scale an interval corresponding to one full stop. I then look at the time opposite the aperture I wish to use—say *f*/22—and note it reads, say, one second. I then recall that the film I am using has a reciprocity failure such that it loses one full stop of film speed at one second, and this I must then enter on the dial by again moving the pointer back down the scale an amount corresponding to one stop. Only then am I ready to read off my actual exposure time at my chosen marked aperture of *f*/22 . . . or 2 seconds.

To summarize, the steps in exposure calculation are:

1. Measure the light.

2. "Place" the subject on the film's scale in order to obtain the rendition you desire.

3. Calculate bellows-draw light loss in terms of *f*-stops and enter it on the meter's dial.

4. If a filter is used enter the filter factor expressed in *f*-stops on the meter's dial.

5. Select the desired aperture and read the exposure time, checking to see if it falls in the region of film reciprocity failure, and if so enter that loss on the meter's dial in terms of *f*-stops.

6. Read the actual, final exposure time.

Light Measurement and Exposure Calculation:

1. Measure the light. (Light value 13)

2. "Place" the subject on the film's scale.(In this case, normal.) Set dial arrow on 13.

3. Calculate bellows-draw. (Minus 1 stop.) Set dial arrow on 6.5.

4. Enter filter factors. (In this case, none.) The dial arrow remains on 6.5.

5. Read exposure at selected f-stop. Add any reciprocity failure factor for film. (In this case, 1 stop.) Set dial arrow on 3.2.

6. Read the actual, final exposure time and f-stop.

Although devised and outlined for close-up nature photography afield, using natural light, the foregoing steps, equipment and techniques apply just as well to any close-up photography—artwork or document copying, commercial illustration, scientific specimen photography and so on. The skills necessary to command the medium, no matter what the purpose, are fundamental, and once mastered, open all the doors.

Cameras

Almost any camera can be adapted, modified, or simply pressed into service to make acceptable, if not high-quality, close-ups.

MAKE YOUR OWN CLOSE-UP CAMERA

Some very fine close-ups can be made with antique cameras such as those that turn up at flea markets and junk-shops. There are, however, two features which must be present to use the cameras for close-ups. These are:

1. A way to look all the way through the camera from the film plane to the back of the lens.

2. A way to hold the shutter open so that it is possible to look not only from the film plane to the lens but on through the lens to the subject.

A few steps can adapt the simple camera. Carefully cut out a piece of standard kitchen wax paper and fit it flat and tight in the same place the film is usually exposed. Tape it over the film plane and open the shutter. A wide variety of optics can be put over the front of the lens. Many kinds of add-on or supplementary lens are available from photo dealers or mail-order houses.

Other lenses can be put in front; or even the lens from a large reading glass. The two lens components must be fastened to a very stiff base such as a board. A heavy paper bag or sack cloth should then be put over the back of the camera just like in the pictures of early photographers with their heads under black cloths. The whole apparatus can be made to slide front and back until an object is in focus not *in* the wax paper but *on* it. The whole setup can be blocked into

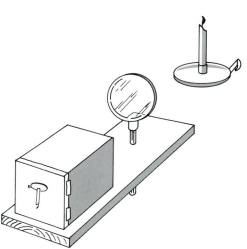

Make Your Own Close-up Camera.

place, the film carefully put in, and a series of test exposures taken. If you keep some records and repeat the exposures that come out best, you will have made yourself an effective close-up camera.

SIMPLE CAMERAS

The basic characteristic of the simple camera is that it does not feature through-the-lens viewing or variable settings such as aperture settings or more than a single shutter speed. Even such cameras can be fitted with a fixed finder and some sort of supplementary lens to allow a closer approach to the subject. Obviously, such a system will require a series of test exposures, but remember, even though modern simple cameras may not have a "T" (time) or "B" (bulb) setting, variation in exposure can be introduced just by stiffly bracing or blocking the camera to prevent vibration and then releasing the shutter more than once.

Providing the subject is stationary, a simple 1 click, 2 click, 3 click, 4 click . . . should suffice with negative film of moderate speed. Or you may wish to sacrifice some sharpness and use faster film for a single click of the shutter.

The wire focal frame is a time-worn device, but once it is set up and tested out by trial-and-error exposures, it, too, can produce good results with cameras that do not have through-the-lens finders.

While it is true that only SLR cameras with their through-the-lens focusing are really adept at close-up techniques, some very fine older cameras fitted with viewfinders, work with close-up subjects and supplementary lenses. The requirement for special viewfinders is due to the effect termed parallax. This is the difference in the appearance of an image when an object is observed from two different angles. Viewing parallax, therefore, results from the difference in angle in the viewpoint of the finder and the lens.

This is especially aggravated in twin-lens-reflex cameras. It is usually solved by mounting the twin-lens camera on a rising frame which brings the taking lens into the precise position of the viewing lens

Parallax and Its Consequences.

Another solution is to set the camera on a tripod or other stand designed to take in a specific area of close-up format and at a precise focussing setting. Some of the highest-quality subminiature cameras use such systems for document photography and even spy operations. In fact, many commercial microfilm units which take thousands of close-ups every day have fixed-gauge arrangements which provide constant maximum sharpness on every exposure.

SINGLE-LENS-REFLEX

The single-lens-reflex (SLR) camera can be purchased in many types and price ranges. It is, when properly equipped, the primary and most reli-

The Single-Lens-Reflex (SLR).

While focussing and viewing, the light passes from the subject through the lens and is reflected from the mirror up to the focussing screen, which is viewed through a pentaprism. When the shutter release is pressed, a rapid sequence takes place: First the mirror springs out of the light path and the light beam strikes the film plane, the shutter passes over the film, the film is exposed, and the mirror springs back into its focussing and viewing position, ready for another subject.

able system for close-ups. However, to gain the maximum image quality, it is necessary to understand how the SLR works and where certain blurs and aberrations can be introduced and how they can be avoided. Basically, all SLR cameras, since their introduction at the turn of the last century, have operated in essentially the same way. This is shown graphically in the diagram.

Many SLR cameras on the market today have the feature called through-the-lens (TTL) metering. It makes the proper setting of the aperture and shutter simple, straightforward, and virtually automatic. However, this same automation can make it difficult, without a lot of modifications, to take close-ups. In addition, viewing screens often have a center spot, which has a different appearance from the rest of the screen, as an aid in focussing. This spot may be fitted with a set of microprisms, or split-image device, so that it is easy to tell when a normal subject is in or out of focus. In close-up work these aids are of limited value, so there should be a plain focussing screen and not one fitted with any central spot device.

The TTL-metering systems that measure exposures so well in standard photography usually take readings from a series of light-sensitive circuits on the mirror surface, behind the prism, or aimed at the shutter/film surface. Unless you are careful, the meter will often give false readings for close-ups. It is important to know what the meter is reading and how to modify the reading to get the proper exposure. Since most of the background of a close-up photograph and much of the area immediately around the subject are out of focus, it is not meaningful to have the meter measure the average amount of light in the scene and base the exposure on this average. Some automated TTL cameras, that give the shutter priority, may set an aperture that is too large for sufficient depth of field. It is important to have a certain degree of manual control over the camera's automatic features.

There are two other less obvious problems. One is the fact that the focussing screen in the 35 mm SLR is rather small, only 24 x 36 mm and, therefore, difficult to focus accurately, particularly since the depth of field is also very small. If possible, a magnifier should be fitted to the eyepiece or a pocket magnifier should be used for critical focussing.

By the very design of the SLR camera, the view is actually cut off during the critical moment of exposure by the flip-up of the mirror. In most close-up situations, this is unimportant; however, in nature or field photography, it may be a real problem when photographing moving objects. The usual answer is to have a frame finder arrangement so that you know the field of view and distance focussed prior to making the exposure. Even in such situations the SLR is still preferred because of the ease of setup and focussing and the portability of its design.

Another important consideration is that SLR cameras allow the fitting of a wide variety of lenses. These can be made by the original equipment manufacturer for the specific camera, made by an independent manufacturer and then fitted by means of a coupling device, or even fitted from a lens system made for a totally different type of camera. It is this ease of interchangeability of lenses and lens components which has made the SLR camera so popular for close-up and other special applications.

The most common SLR cameras are without a doubt 35 mm film models. However, many advanced amateurs and professionals use larger film formats. The most popular of these use 120 roll film and yield $2^{1}/_{4}$ x $2^{1}/_{4}$-inch negatives. One of these cameras is designed to be used in close-up photography up to 1:1 or "life-size" magnifications with almost no accessories. Generally, the chief drawback is the cost of the basic camera and accessories or special lenses for close-up photography.

Since close-up photography is so important in science and industry as an experimental or recording technique, there are a number of special photographic systems on the market which are designed to operate totally in the close-up range. They feature special close-focussing zoom lenses which provide high resolution and magnification up to 50 × or more and 90-degree angle viewfinders for low-level camera focussing. They usually have totally automated exposure systems, electrically operated shutters and film advances and are fitted with beam-splitters which send most of the light to the camera but divert some to a viewfinder. By this means, they avoid the "moment of blindness" which overcomes all other SLR designs. While very complex and expensive, these technical cameras still are able to compensate for all of the basic problems mentioned above.

The WILD-HEERBRUGG M-400 Camera. A workhorse for close-up and photomacrographic techniques.

The LEITZ ARISTOPHOT Macro-View Camera. An excellently designed sheet-film view camera, shown here with a specially compounded PHOTAR Lens and complementary condensers.

BASIC CAMERA AND LENS COMPONENTS

Modern, fully integrated SLR cameras would seem to take all of the calculation and exposure-setting out of close-up photography. However, the automation is based on assumptions that work well in general photography but not necessarily in close-up situations. For this reason, it is a good idea to review and to understand each of the functions of your camera even though it may normally be controlled by one of those wonderful little electronic chips. The first, and most baffling one, is the aperture control.

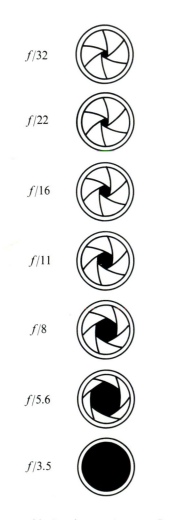

Variable-Diaphragm Aperture Control.

Aperture

The aperture is the variable diaphragm used to control the amount of light reaching the film. It does not stop or start the light but it does control the amount of light passing through the lens. At the largest opening—the lowest *f*-number—the diaphragm blades of the aperture virtually disappear into the sides of the lens barrel. At the smallest opening, there is a black iris-like closure in the lens with only a tiny hole in the center. In modern SLR cameras with automatic diaphragms, the aperture remains wide open most of the time. The diaphragm closes down to the opening selected by the TTL meter a fraction of a second before the shutter opens; it then opens up all the way after the shutter has exposed the film and closed. While it is often stated that there are equivalences between one aperture and shutter combination and another, this is not completely true. For example, it is possible for a TTL meter to select any one of the combinations, $f/4$ at $1/1000$ second, $f/5.6$ at $1/500$ second, $f/8$ at $1/250$ second, $f/11$ at $1/125$ second, and $f/16$ at $1/60$ second. However, a closer look demonstrates that in the *close-up range* these are not equivalent apertures. An aperture of $f/4$ is somewhat large for any significant depth of field and $f/16$ will most likely not yield sufficient contrast.

On the other hand, while apertures of $f/5.6$ through $f/11$ will work in the close-up range, there will have to be some consideration of any accessories which have been added to the lens and if any EIF compensation must be added. You will find that for the overwhelming number of close-up photographs there are really only one or two apertures which will fulfill all of the required effects and thus a single compromise will emerge. The aperture is so closely associated with the shutter that the two must be considered together.

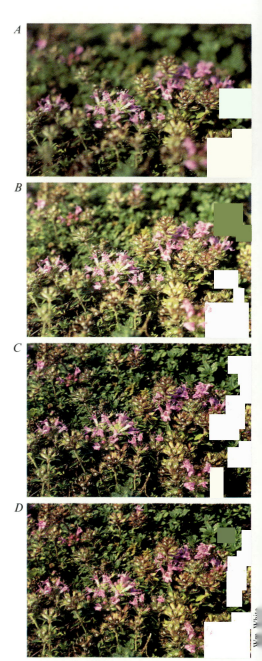

A photo series showing progressively increasing depth of field as the aperture is closed down. Notice also that the exposures, although mathematically equal, do not give identical results. The camera was a NIKON with a 55 mm lens. The exposures were as follows: A) 1/125 sec, f/3.5; B) 1/60 sec, f/5.6; C) 1/4 sec, f/16; and D) 1 sec, f/32.

Shutter

Most of today's cameras have what is called a focal-plane shutter. It was invented in the very early days of photography but brought to perfection in the 35 mm camera format by Oskar Barnark with the first LEICA Camera. In effect, the shutter consists of a set of miniature curtains, usually made of cloth or a very hard metal, such as titanium, that form a slit as they pass over the film, exposing it to the light. In a focal-plane shutter, the curtain is immediately in front of the film at the back of the camera. It has two very great advantages: First, it stays within the camera body and is totally independent of the position or extension of the lens, thus allowing lens interchangeability. Second, it can be positioned back far enough to allow a mirror to swing in front of it and accounting for the single-lens-reflex design. Since this design pushes the lens forward so far, it has made the older symmetrical lens very difficult to use on SLR cameras. While the shutter design has little bearing on general, everyday photography, it does make life more complicated in close-up photography.

Older cameras that used ground-glass backs for focussing and for framing allowed a direct view of the image that the lens was "seeing." They let the photographer see his subject exactly as the lens system projected it onto the film. There is now no SLR camera on the market with this capability. Accuracy of focus in the SLR depends on the absolute alignment of the focal plane and the pentaprism or focussing screen.

Shutter speeds of SLR cameras are becoming more and more accurate as electronic timing and tripping devices are incorporated. The typical SLR has a series of speeds, each one-half the speed of the next—from 1 second up, thus: $1/2$, $1/4$, $1/8$, $1/15$, $1/30$, $1/60$, $1/125$, $1/250$, $1/500$, and $1/1000$ second.

Focal-Plane and Iris Shutters.

View Camera.

Since the lead curtain must open and then the trailing curtain must close, not all $1/1000$-second shutters are actually open only $1/1000$; this only means that any particular spot on the film is exposed to light for just $1/1000$ of a second. The shutter may actually take several thousands of a second to travel across the complete expanse of the film. This is why electronic flash units are usually used only at a slower speed of $1/60$ or $1/125$ second because that is the fastest speed at which the entire film area is exposed to the light at one time.

All of this may sound quite complicated but it points to one fact; the focal-plane shutter has a character of its own and that character is more obvious in the close-up mode. For instance, high-speed exposures of $1/1000$-, $1/2000$-, or the now available $1/4000$-second do not work well in the close quarters and with the small apertures of close-up; to use such exposures properly and to take advantage of their speed requires more light than the tiny scenes of close-up photography can properly stand. If such speeds are required, as they often are in scientific applications, a high-speed strobe light or flashtube should be used. On the other end of the time spectrum, with the slow speeds that are more common in close-up photography, most focal-plane shutters give rather high vibration effects, often a distinct jerk, as they pass across the film plane. Motor-drive cameras may also give problems with vibration. With the use of fully automated or programmed SLR cameras, it is best to use the aperture priority mode and a solid support, even if it means a rather slow shutter speed.

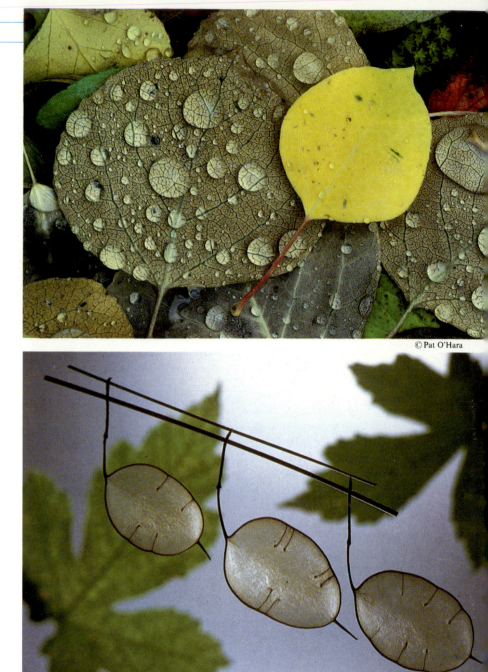

© Pat O'Hara

W. R. DeHaene

Exposure Meters (Internal and External)

The largest percentage of currently available SLRs have internal, through-the-lens (TTL) exposure meters that can be set for a particular film speed. Some cameras have a dial that allows the setting to be varied slightly to give $1/2$, 1, or 2 aperture stops of exposure compensation. A match-needle or a light-emitting diode (LED) usually indicates what the shutter speed-aperture combination is in the viewfinder. The question now arises as to what the meters are actually measuring. This answer is very important in close-up photography because one of the basic procedures is to highlight the principle subject or structural detail and to darken and subdue the foreground and/or background. It is vital to know exactly where in the image area the meter is actually measuring the light.

Today's meters are very sophisticated; however, they are usually based on statistical studies of the average photographer's picture-taking habits. Since the vast majority of photographs taken around the world are of children and pets, the statistics favor a sort of center-weighted triangular field. Such a field is exceedingly rare in close-up photography. In fact, a sampling of over 5000 of the author's slides show 85 percent of the subjects to be in a circular object pattern, 10 percent in a band across the middle of the frame, and 5 percent other patterns. The TTL meters on most SLR cameras would be accurate for only 5 percent of the exposures. Most meters read either all of the frame or several spots on the frame and take an average of the readings to give a result. Such readings will yield incorrect exposures with most close-up photographs. Therefore, you must know precisely what spots or zones your meter reads and you must also know how your meter weighs those spots; for example, does it give 60 per-

cent weight to the reading at one point and 20 percent each to two others, or does it read two and divide the average equally? Camera manufacturers can give you this information about their products.

Most meters read light intensity without any regard to the color balance of the light being read. Since meters are often more sensitive to blue light, the scene may appear different in light intensity to the meter than to the eye. If you do not have a camera and are looking for one with particularly good components and features

Two photographs with similar subject matter, but completely different exposure conditions. The circular composition of aspen leaves presents a fairly low-contrast picture. A center-weighted through-the-lens (TTL) meter would read the scene properly because most of the densities are represented in the center of the frame. The composition of leaves and Silver Dollar seed pods, on the other hand, presents primarily a backlighted highlight area in the center of the frame. A center-weighted TTL meter would give a false reading and the leaves would be underexposed and silhouetted. The seed pods would lose their translucency and become darker.

for close-up work as well as for general photography, get one with "spotmeter" capability that enables you to read only a very small spot directly in the middle of the frame.

The author has discovered over the years that external spot meters are much more useful in close-up photography than TTL systems. They are usually more sensitive, and if you get one with "zone system" markings, you can, with a little practice, make very precise judgments as to the proper camera settings. Standard incident and reflected light meters measure much too large an area to be used for close-up photography.

The external "spot meters" are accurate for very small areas, usually an angle of about 1 degree of the total scene from the measuring position. This area is shown in the meter viewfinder by a tiny circle or spot. The spot meter can be pointed at important, detail-containing, highlight areas (not at what are called pointlight or specular highlights of the object, because they contain no information) and read. If the process is repeated over the entire scene for both dark areas and light areas that contain information, a simple calculation can be made giving the average reading. The formula is:

$$AvR = \frac{TR}{NR}$$

where AvR = average reading
TR = total of all readings
NR = number of the readings.

Thus, if we have a close-up scene with 10 different areas reading 11, 11, 6, 6, 6, 5, 4.5, 9, 7, 12. The total or NR = 11 + 11 + 6 + 6 + 6 + 5 + 4.5 + 9 + 7 + 12 = 77.5, which is divided by the number of readings; $\frac{77.5}{10} = 7.7$.

The aperture and shutter speed can then be read off the appropriate scale.

Another problem with exposure determination is more a problem of photographic film emulsions than the meters themselves. This is due to the reciprocity-failure effect. A specific film may be exposed at $f/2.8$ at $1/125$ second or $f/4$ at $1/60$ second or even $f/5.6$ at $1/30$ second and exhibit pretty much the same result because these exposure combinations are fairly *reciprocal*. But as the exposure times become very long or very short, this reciprocity fails, so that 2 seconds may not yield twice the exposure that 1 second will yield. Many meters will dutifully show these as continuing to be reciprocal. Failures usually occur at both ends of the scale, often with speeds higher than $1/1000$ second or slower than $1/2$ second. (A typical reciprocity compensation table is shown on page 94.) Development time adjustment may also be necessary to achieve the correct contrast (with black-and-white films).

CAMERA MOVEMENT, EXTENSION, AND VIBRATION

One of the chief problems with close-up setups is the need to keep the apparatus from moving. This is because many of the exposures are $1/2$ second or longer, and there are long extensions of the lens and intermediate components such as extension tubes or bellows. The first rule is to brace the whole camera unit at its center of gravity if at all possible. Better quality bellows will often have a tripod socket in the brace that holds the camera. Use the socket in the brace and not the camera socket whenever possible. The best practice is to put together a device that allows both a back and front tripod brace to be attached.

When choosing a tripod, too big is never big enough! The author uses a commercial TV camera tripod that outweighs the SLR on it by 100:1. This usually assures reasonable stability. Even with a massive support, if the camera and its components are not balanced properly, they may still shudder when touched. Using a cable release or other remote release will help. Another aid is to use the camera's self-timer; this gets the hands and the pressure on the release button away from the camera body in sufficient time to let the shudder dissipate before the shutter actually makes the exposure. In field use, a heavy tripod may be inconvenient or impossible. In such cases, use sandbags, rocks, logs, or any such convenient object with a mass great enough to absorb any slight movement. The wildlife close-up photographer must use his or her own ingenuity.

External vibration is another problem. At many laboratory or industrial sites, certain types of vibrations cannot be escaped. Refrigeration units, centrifuges, air conditioners, and machine tools all produce their own vibrations and, what is worse, set up sympathetic vibrations in other objects in the same area. Most annoying are large-scale vibrations transmitted through floors and walls. The only resort in such cases is to dampen the vibration with air pucks or air cushions placed under the camera setup. If it is a permanent laboratory setup, then the whole arrangement of camera, support, lights, and subject stand can be built into a cabinet and everything dampened against vibration as a unit. A particularly interesting problem arises with close-up in holography. The tolerances are so fine that nearly absolute control of vibration is vital. The only practical answer is to use what is called a "sandbox"—a large walled-in area filled with sand— that, due to its great weight, is usually located in the cellar of the building. The components of the photographic system are set up in the sand, thus dampening all vibrations.

Lenses and attachments

The one significant feature of all close-up techniques, as compared to close-focus techniques, is the position of the lens with respect to the camera and the subject. By some means it must be extended beyond its normal focussing position. The lens can even be reversed on the camera by using a connector ring to attach the front of the lens to the camera with rear element of the lens facing the subject.

Let us consider first the uses of the extension tube with the standard 50 mm lens.

Extension Tubes

Extension tubes are metal rings or tubes which may be used singly or in groups to extend the lens beyond the camera body. They can be simple threaded aluminum tubes or have bayonet adapters specially designed to fit specific cameras. Tubes should be painted with flat black paint or coated with rough black flocking material inside to cut down unwanted reflections. They usually are supplied in sets of three and a common grouping is 6, 18 and 25 mm. Some of the more widely used camera models have had all sorts of tube lengths made for them by both the original company and by independent manufacturers. Tubes can be found from 5 mm up to 150 mm in length. They are rigid and provide a very strong and dependable support for the lens. Some even have provisions for connecting the automatic diaphragm control. Extension tubes are also inflexible, and focusing or framing must be done by rearranging the tubes or moving the camera/tube/lens back and forth as a unit. The magnification one gets with such tubes is not great, typically between

Extension Tubes.

Wm. White

A photo of some Russian printing taken with the camera rig shown in the above photo. The effective aperture of f/128 at a 5 sec exposure for a 6 × magnification was just about the limit for the unit. Note the depth of field is so shallow that a slight curl in the paper put the left-hand Cyrillic character out of focus. The film is KODAK EKTACHROME 64 Film. Reproduced here at 21.6 ×.

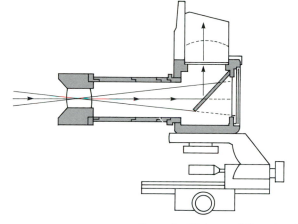
Extension Tubes and Focusing Cradle.

A typical long-extension rig from the mid-1940s, with a screw-mount LEICA Camera, a mirror reflex housing, a symmetrical SUMMITAR Lens, and a complete set of tubes.

$$d = F \times m$$

where d = the distance (in millimetres) of the extension

F = the focal length of the lens

m = the magnification desired.

(See the chart on pages 91 and 92)

35 mm Camera with Bellows.

0.24× up to 3×. However, this is a very useful range. The 50 mm lens must be extended 50 mm beyond its normal position in order to obtain an image-to-object ratio of 1:1. In fact, the total extension is always (1 + m) x focal length, so that 2× would require the lens to be 150 mm from the film plane (basic focal length of 50 mm plus 100 mm of tube extension). In theory you could extend the lens further and further out, but practically there are very serious limitations. The exposure-increase factor $(1 + m)^2$ shows that a 9× exposure compensation is necessary for the 2× magnification. Thus the *f*/8 aperture setting is now an effective *f*/22. If you want to retain an effective *f*/8, you must now open the extended lens from *f*/8 to *f*/2.8. In addition, the depth of field at 2× is less than 1.25 millimetre in front and in back of the object and the working distance is less than 75 mm from the film plane!

The formula for calculating the extension needed for using any focal length lens is simply

Thus, for example, if we wished to find the distance of the lens extension required for a 50 mm focal length lens to yield a magnification of 3×, we merely multiply them and the answer is 150 mm. It can quickly be seen that if we try for 10× magnification, the limit for all practical purposes of close-up, and wish to use a 50 mm lens, we are going to have to use a 500 mm extension. This will mean a tube length of a little under two feet, but it will also mean an exposure increase factor of 121× or a need to multiply the exposure time by 121. The depth of field would be so shallow that only the surface of a two-dimensional object could be photographed, such as a postage stamp or a portion of a document. If that is what you must photograph, then an extension tube or a series of tubes may satisfy your requirements. However, there are other ways which are more convenient, and the most commonly available of these is the bellows.

Bellows

Just as with SLR cameras, there is a wide variety of bellows apparatus available on the market. They range from simple little one-rail devices, which can be folded to fit into a pocket or purse, to complex devices with heavy bases, provisions for shifts of camera and lens, like a view camera, and even automatic coupling to the through-the-lens-metering system. Basically, they allow the distance from camera to object and from lens to camera to be changed by a simple twist of a knob. No matter how well they are made, bellows attachments are not as solid and fixed as extension tubes. They are, therefore, more difficult to use handheld or in the field. However, they are certainly the most flexible apparatus for extending the lens for close-up photography.

While there is some variation in the lengths of bellows, most of those

made for 35 mm cameras will extend to 150 or 250 mm. The same extension problems of exposure increase and loss of depth of field which are apparent with extension tubes apply to bellows as well. As a rule, the double-track bellows is much to be preferred and a camera attachment that allows the camera to be rotated for vertical as well as horizontal format is a good idea. Bellows will provide up to 8× magnification, which is useful in photographing very small flat objects such as coins. Bellows can also be fitted with special short-mount lenses that allow the using of long focal lengths to provide longer working distances.

Another interesting arrangement that can be accomplished with bellows is the use of a telephoto lens to obtain close focusing at low magnification from a considerable distance. The bellows can be combined with extension rings and different types of lenses. The camera/bellows combination should be firmly attached to a strong tripod because the unit is more subject to vibration effects than are rigid extension tubes.

While there are some advanced bellows systems that allow many different swings and tilts for perspective control, they are often not practical unless required for a very specific type of photograph. With the normal lens in a reverse position on the bellows, slightly higher resolution and greater magnification beyond 1:1 may be possible.

Bellows work best when they are used in a vertical arrangement with the camera, or the brace that holds the camera, fastened to a copy stand. Then the camera is properly supported and the lens axis is perpendicular to the base on which the subject is placed. In such a setup, there is little unsupported weight and the lens hangs neutrally in its attachment. If a horizontal arrangement is used, there is always a chance for the lens to sag

in the front brace of the bellows. While some bellows devices can hold the lens in proper alignment with the camera, they are usually large and heavy, which makes them more difficult to use in other ways. Some bellows will operate with the through-the-lens metering system of the camera and with the automatic diaphragm. While these appear to offer advantages, it is doubtful that they really do. Where metering must be interpreted and compensations made, it is better to understand the principles of close-up technique so that you can set the aperture and the shutter speed without the aid of such device-automation. The simple fact of the matter is that such automation rarely provides all the compensation required.

Supplementary Lenses.

Close-Up or Supplementary Lenses

There is another way to extend the lens of a camera to make close-up photographs. This involves not mechanical, but optical, extension. Equipped with a simple supplementary lens attached to the front of the camera lens, the camera can approach closer to the subject than the normal close focus of the lens will allow. This provides a degree of magnification. Such lens additions are called by various names, "close-up lenses," "proxars," "portrait lenses" (not really an accurate description), and "supplementary lenses." They are rated according to strength by a system of *diopters*. The diopter is

equal to the focal length of the supplementary lens divided into 1. The formula is:

$$d_i = \frac{1}{F}$$

d_i = diopters
F = focal length in metres

Thus, if a lens has a diopter rating of +3, this means that it has a focal length of 0.33 metres or 333 mm, so that if it is attached to any lens set at infinity it will provide a distance from lens to subject of 333 mm, or about 13 inches. This will give an object to image ratio of 1:6.3 or a magnification of 0.16×.

Supplementary lenses can be found in most diopter strengths from +1 to +20. They should be mounted as close to the main or prime lens as possible. The supplementary lens has another advantage in that it requires no exposure compensation. However, results are usually best if the main lens is stopped down to *f*/8 or more because the supplementary lens may add obvious aberrations at the edges of the image. One supplementary lens can be attached to another and such a set will work, but only poorly. In fact, most manufacturers of supplementary lenses recommend that no more than three be linked in series. Even this is too many for good results. Two is really the practical limit and then only low power lenses should be used, such as +1 and +2 or +2 and +5. The +10 supplentary lens is really the practical limit for use either in sets or for the single strength. The +10 lens yields a magnification of about 0.5× and a distance from lens to object of 10 cm, but with a depth of field of only about 1.5 mm. The main lens focusing ring will not really provide much in the way of focusing range with a supplementary lens attached.

The supplementary lens can be a very useful device in making close-ups in the range from 60 cm (the closest

focus of a standard lens) to about halfsize (0.5 ×). Indeed, the + 20 supplementary lens will reach 1:1, but it is obviously not the best way to do it because of the possible aberrations. On the other hand, if all you ever want to take are occasional close-ups of flowers or pets, then supplementary lenses will do nicely for such large objects and low magnifications.

Supplementary lenses are usually sold in sets and for almost any type of SLR. The very high-quality ones are fairly expensive but will give quite good resolution. The most useful seems to be the + 5 or + 6 which give a meaningful magnification of about 0.32 ×. The screw-in type is better than those that must be mounted in an adapter ring or sunshade. Such an additional device places the supplementary lens too far away from the primary lens front surface and may increase aberrations in the image.

(See page 93 for charts regarding supplementary lenses.)

Teleconverter.

Teleconverters

With the popularity of 35 mm SLR cameras has come the revival of an old idea in a form called teleconverters. These are multiple-element lenses designed to go between the camera lens and the camera to increase the focal lengths of medium-range telephotos. Thus a 2 × teleconverter will turn a 135 mm medium telephoto into a 270 mm lens with a narrower angle of view and a much smaller *f*-stop; in effect, twice the marked *f*-stop. With care, a teleconverter used with an extension tube

and a 50 mm lens will make a useful close-up device. It will be almost non-focussing, so you will have to go back to the method of moving the whole camera/lens system back and forth to focus. However, with a high-quality teleconverter, a reasonable image can be made. The best teleconverters are matched to a specific lens and to a particular focal length.

Occasionally someone praises the virtues of mixing some of the components we have covered; they say that an extension tube plus a teleconverter plus a main or prime lens plus a supplementary lens will produce better close-ups. This is, unfortunately, untrue. The more glass and tube it goes through, the more the image is degraded. When you set up and try out close-up components, the rule is *the simpler, the better*. If you achieve the required magnification with the fewest components, that will yield the best image.

There is one very sad fact about any such systems: When components are coupled, the *correction factor for the extension of each must be multiplied*. Thus if two teleconverters of 3 × magnification are hooked together, you will get a new magnification of 9 × but the effective aperture will not be smaller by three stops but by nine! If the shutter speed is to be lengthened to compensate, the situation is even worse, because the shutter speeds also must be multiplied so that the shutter speed increase of 8 times, required for a 3 × magnification, becomes a shutter speed increase of 8 x 8, or 64, for two 3 × teleconverters used together. To add to the difficulty, through-the-lens meters that are quite accurate at normal ranges of light and film speed may not operate, or may become woefully inaccurate when they are used with lower light levels and lengthening shutter-speed compensations. This will be examined in our section on Exposure Control beginning on page 60.

Standard or Wide-Angle Lens with Reversing Ring.

Enlarging Lenses

A high-quality enlarging lens with a standard, usually LEICA, thread makes a very fine close-up lens and will produce high resolution and a usable magnification range. However, they commonly have a top aperture of *f*/4.5, and cannot be coupled to automatic through-the-lens metering systems of SLR cameras.

Standard or Wide-Angle Lenses with Reversing Rings

In the ultra-close-up range where the image-to-object ratio is greater than 1:1, substantial gains may be made by reversing the lens so that the back of the lens faces the subject. Many SLR models have, as accessories, adapters that will couple the lens to the camera in the reverse position. Some adapters even have devices that provide for use of the automatic diaphragm. One 2¼ x 2¼ SLR actually has a coupling device built onto the camera body and calculation tables on the camera for reversing the lens. Thus far, the same feature is not available on any 35 mm SLR models. The technique of lens reversal works well only for standard focal-length lenses, 45 to 55 mm on 35 mm cameras and 75 to 85 mm lenses on 2¼ x 2¼ cameras. One exception is the use of moderately wide-angle lenses, such as 35 mm focal lengths, on 35 mm cameras. These, too, will often work well in reverse. In fact, as the magnification is

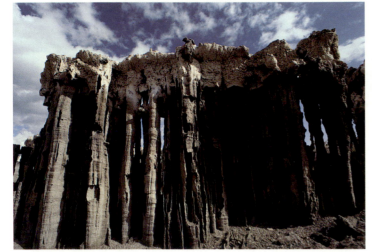

B. "Moose" Peterson/WRP

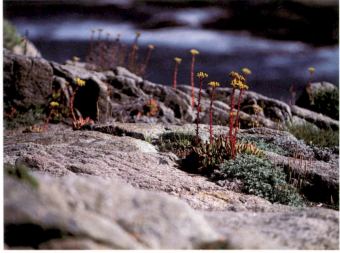

B. "Moose" Peterson/WRP

Above: These fragile sand tufas of Mono Lake are a mere 28 inches tall. To give them a towering appearance, they were photographed from ground level with a 15 mm lens. Close-up photography with a wide-angle lens is a technique often used to distort the scale of an object.

Below: When photographed from above with the same lens, the actual size of these delicate structures is apparent.

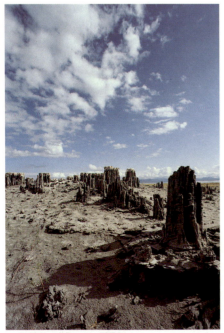

B. "Moose" Peterson/WRP

increased to 1:1 or greater, the reversed position is the preferable positioning orientation. There are, as usual, certain procedures that must be followed. In tight working spaces, when the lens is only a few millimetres from the subject, there is no lens barrel shielding the bare rear element. If a filter or an open ring cannot be mounted, great care must be taken not to bump the glass against the subject and inflict a scratch. Another problem is that, since there is no shielding of the rear element, all kinds of stray light beams may pass into the lens and degrade the image. A cardboard, or even a black paper ring, should be taped on the lens as a lens shade and reduce such incident light.

A reversed lens will have two characteristics. First, it will greatly increase the magnification. For example, a standard 50 mm lens that will focus down to 60 cm and yield an image of 1:10, when reversed, will yield an immediate image-to-object ratio of 1:1.3 and a lens-to-object distance of 5 cm. There is another factor that must be considered; the differing performance of symmetrical versus asymmetrical lens in the reversed position. In past years, many authors writing on close-up photography have lauded the superiority of the reversed lens position. This was true be-

Another example of the use of a wide-angle lens and low angle of view. These relatively small dudleyas at Point Lobos have a precarious perch on a sea wall. By using a 35 mm lens, the photographer was able to include the rock ledge in the foreground and ocean in the background.

cause most SLR lenses were indeed asymmetrical. They were designed that way to allow space enough in a SLR body for the mirror to swing out of the way. On the other hand, many of the interchangeable lenses for the rangefinder 35 mm cameras were nearly, if not precisely, symmetrical.

What is this business of symmetrical versus asymmetrical anyway? As mentioned earlier by Dennis Brokaw, a symmetrical lens has identical sets of optical components on either side of the diaphragm, or nearly so. This is true of many of the large commercial copying lenses and some enlarging lenses. With a symmetrical lens, the image will focus in essentially the same plane whether the lens is mounted normally or reversed. This is not true for many large-aperture normal camera lenses, for telephoto lenses, or for inverted-telephoto wide-angle lenses. Such lenses are asymmetrical, have a different set of optical components on either side of the diaphragm, and will have a different focal plane when mounted in reverse.

Pupillary Magnification: Front of Lens.

Pupillary Magnification: Rear of Lens.

Another effect that results for reversing an asymmetrical lens is *pupillary magnification*. Take a telephoto lens—let us say the 90 to 135 mm lens of a typical SLR—and carefully close the diaphragm just enough so that the edges of the blades are visible. Hold the lens at arm's length and look through it. You will notice that the size of the aperture appears to be different when viewed from the front and the back. The back view of the aperture (exit pupil) to the diameter of the front view of the aperture (entrance pupil) is the pupillary magnification. The formula is simply:

$$P = \frac{Dex\text{-}p}{Den\text{-}p}$$

P = pupillary magnification
Dex-p = diameter of exit pupil
Den-p = diameter of entrance pupil.

The best way to measure the diameters is to hold a millimetre rule at

arm's length over each end of the lens and observe very carefully the width of the aperture as viewed from front and rear. There are, of course, more elegant ways to do this, but this will give a reasonably accurate ratio for your purposes. But why do you need one more measurement and calculation? Simply because we misled you earlier in this book. If you think about the formula which we gave earlier for calculating the EIF (exposure increase factor), you will discover that it is for symmetrical lenses *only*. The formula was: EIF = $(m + 1)^2$. But the formula for the exposure increase factor with asymmetrical, or as they are sometimes called unsymmetrical, lenses is:

$$EIF = \left(\frac{m}{P} + 1\right)^2$$

When the asymmetrical lens is reversed this becomes $(mP + 1)^2$.

where EIF = Exposure Increase Factor
m = magnification
P = pupillary magnification

For example, if you have a lens with an exit pupil diameter of 31.9 mm and an entrance pupil diameter of 44.0 mm, you can use the formula as follows: $P = \frac{31.9}{44} = 0.72$ which is

the pupillary magnification. You can then use that figure in obtaining the EIF for a magnification of, let us say 4×, so that:

$$EIF = \left(\frac{4}{0.72} + 1\right)^2 =$$

$$(5.5 + 1)^2 = 42.25.$$

You can, of course, discard the decimal places and the resultant EIF is 42. So you must multiply your exposure time by a factor of 42.

While this all may seem like so much excess scientific purism, the fact is that it can make an enormous dif-

ference in the results that you achieve. For example, if the lens you are using has a pupillary magnification of, let us say, 0.7 (many telephotos for 35 mm have ranges of P between 0.4 and 0.7), and you take a 1:1 photo, the expected EIF, using the symmetrical formula would be a simple 4, or four times the exposure time. But the actual value, since it is an asymmetrical lens, is 5.8! A photograph taken at the 4× EIF would be underexposed.

Fortunately, however, the problems with reversing lenses have slowly begun to pass into photography's historical past. In the last few years, a whole variety of nearly symmetrical special "macro" lenses has been introduced. Many of these lenses are either nearly symmetrical or of such a quality that they really do not need to be reversed to yield high-quality close-up results.

Standard Lens Reversed on a Longer Focus lens.

Standard Lenses Reversed on Longer Focus Lenses

It is possible to take a moderate length telephoto lens such as a 100, 135, or even 200 mm lens and place a shorter focal length lens on it in the reversed position. The effect is much the same as using an extension tube or bellows, but the compensation factors are a bit clumsy, and it is really not much more than a substitute pressed into service when no other equipment is available. For one thing, few manufacturers make lenses of the two focal lengths that can be coupled in this way, and the EIF of such a setup is worse than normal as there are now not just one but two asymmetrical lenses involved.

Macro Lens.

Zoom and Long-Focus Lenses with Close-Focus Provisions

Since the zoom lens has gained such enormous popularity among photographers who use 35 mm SLR cameras, many have been introduced with what are called "macro" or "close-focusing" provisions. There is a sense in which these are misnomers; these lenses are certainly not macro in the sense of the term photomacrography

Zoom Lens with Close-Focus Provisions.

(the specialized technique of magnification in the range 1:1 up to 10:1 that requires very specialized equipment). But some of these lenses will work well in the medium close-up range— closer than such lenses can usually be applied. As with all zoom optics, there are compromises involved and the application of them in close-up is only in a narrow range. They can certainly be used for magnification from 1:9 to as much as 1:5 with appropriate accessories, and some come reasonably close to approaching 1:1.

There is one very special group of lenses which is becoming more important in close-up photography; mirror lenses or catadioptrics can be modified or built with internal lens shift provisions to yield high-resolution magnified images from some distance. Several specific instruments will now yield a massive 65 × magnification from a distance of over a metre! This certainly will contribute substantially to the potential of close-up photography and photomacrography.

Macro Lenses

There are lenses available for SLR cameras that are mounted in extended helical tubes to allow focussing up to 1:1 magnification without supplementary tubes or bellows. The first of these, which is still usable, had a 40 mm focal length, and was later followed by a 35 mm lens with a double focussing mount. Since 1970, a whole array of such lenses has appeared on the market. They range from 50 or 55, through 60, 90, 100, 105, 135, all the way to 200 mm in focal length. Many have specially engineered extension tubes supplied with them that provide for the coupling of through-the-lens metering and automatic aperture control. When mounted on a high-quality, modern, electronically controlled SLR with a matte or plain focussing screen, they are a dream come true for the close-up photographer.

Even though this lens/camera combination circumvents many of the problems and makes the calculations within the camera, the use of such lenses and cameras still requires a certain degree of finesse for best results. There are some things that even the best programmed circuits still cannot anticipate. Basically, these lenses are of better quality than the standard ones of the same focal length; however, they usually have fairly small apertures—typically, $f/3.5$ has been the maximum. A few have been available up to $f/1.9$, but these were not at their best optical performance at that wide an aperture. Another problem has been that, beyond the close-up range or in low light, they are very difficult to focus. In fact, if you can get a magnifying viewfinder for your particular brand of SLR, you should use it with these lenses. Note also that the longer the focal length of a macro lens, the more difficult it is to focus.

A Note About Macro Lens Markings

There are a number of systems of markings that appear on various manufacturers' macro lenses. Some lenses that have been on the market for a few years have very poor markings, giving the depth-of-field scales only for one actual magnification setting. Some systems are very complex and one even has a hood arrangement on the extension tube that masks out the markings on the lens barrel, replacing them with those on the extension tube. Be sure to read the instructions that come with the macro lens you purchase. If the markings are not informative or do not apply to your requirements, you can make a small scale of your own and glue or tape it right to the lens barrel. This will save you a great deal of time and aggravation.

Modern macro lenses usually can be fitted with special extension tubes that provide for 1:1 image-to-object ratios. In such use there is often less than 10 cm (4 inches) working distance and certain subjects will be hard to light at that range. Very important exceptions are longer-focus macro lenses, such as the 90, 100, 105, 135, and 200 mm focal-length units, that can be substituted for the equivalent focal-length standard lens. For close-up work they will outperform the standard telelens of the same focal length, and they are superior to any zoom lens set at that same focal length. Many have an optical performance superior to almost any other SLR lens on the market. These telelenses also provide the very long working distances that are essential for nature work and some types of industrial photography.

All the modern macro lenses can give greater magnification with extension tubes or bellows. However, the longer and heavier lenses will tend to show some vibration effects on long bellows extensions. Since many of these long-focus lenses are symmetri-

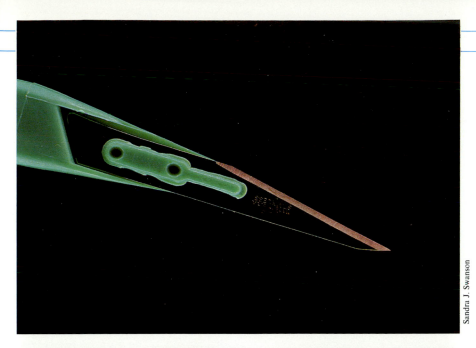

Sandra J. Swanson

Disposable Scalpel: This unusual lighting treatment of a normally colorless subject was accomplished by using an ARISTOGRID Light Box (8 x 10-inch) and strips of colored paper to provide the accents. The scalpel was suspended above a black background.

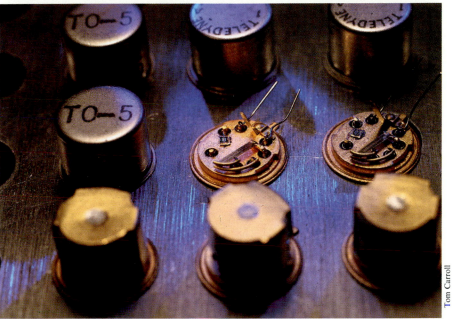

Tom Carroll

Overall and selective lighting of 1:1 close-ups of electronic components for a corporate brochure. Colored gels were used on photoflood lamps balanced for 3400 K and KODAK EKTACHROME 160T Film (Tungsten), pushed 1 stop.

Client: Electronic Systems, Inc.

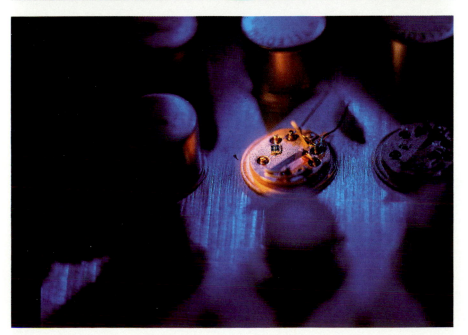

cal in design, or very nearly so, there is no gain in reversing them. Some manufacturers of these longer focal-length macro lenses also provide specifically designed and optically corrected tele-extenders for them. The entire package of a 100 to 200 mm macro lens with a bellows and tele-extender may be expensive, but it will outperform many other devices on the market and, since it can double as a standard lens, it is well worth the investment. In fact, the author has used macro lenses as standard lenses in all cases of general photography for over thirty years. As for comparisons between them, they are virtually identical in optical performance at an aperture of $f/8$ to $f/16$ but do show some very slight variation at their maximum aperture. This is usually not enough to be readily visible except in very big enlargements. But at the very smallest apertures—and most can be stopped down to $f/32$—there is again a slight loss of image quality due to diffraction.

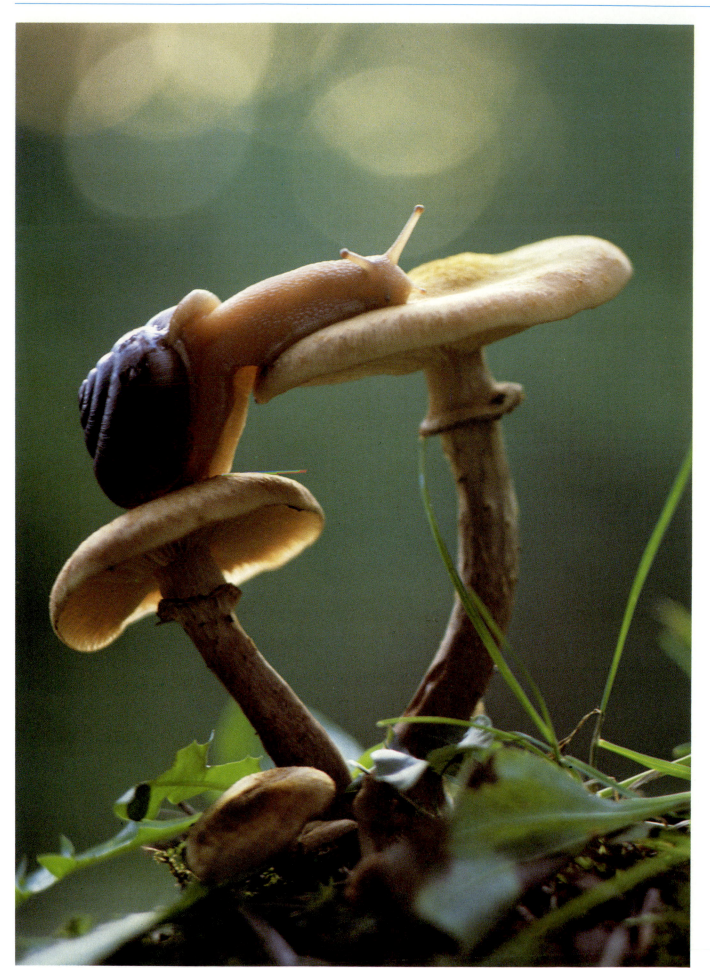

Smooth Green Snake: Here, shutter-priority is of maximum importance. Depth of field suffers, but the photo is effective and sharp in the important place. The subject was photographed from ground-level (wet-belly photography) in natural early morning light. Because of the early morning coolness, reptiles are sluggish and move slowly, making photographing them slightly less difficult.

There are certain basic procedures for using these macro lenses. These are:

1. Always focus at the largest aperture, then stop down to check depth of field visibly. Look for what is *in* focus in the stopped-down mode and remember that *the camera will record a different image from what the eye sees.*

2. If you are using a camera with TTL metering, make sure, first, that the shutter speed is fast enough to capture the movement of the subject and, second, to allow for handheld operation.

3. Observe the differences in lighting between the subject and the foreground-background to determine

Shades of Alice in Wonderland: The backlighting of this beautifully composed scene gives excellent contrast to delineate the subject. The white-lipped snail on the mushrooms was backlighted by early-morning sunshine diffused by bushes several feet behind the subject. A small, white reflector bounced fill-light back onto it.

that the main subject stands out. This will take some practice but it is very necessary to grasp as part of good close-up technique.

Micro Objectives and Reversed Movie Camera Lenses.

Micro-Objectives and Reversed Movie Camera Lenses

True macro lenses are really developments of low-power microscope objectives. They are small and very highly corrected. They must be used with great care but can produce very good resolution at significant magnifications. Only a few manufacturers produce them, and in all cases these companies also make sophisticated research microscopes. Such lenses must be well braced against vibration and coupled to quality cameras. These lenses can be used with some 35 mm SLRs, but they work even bet-

ter with 2¼ x 2¼- or 4 x 5-inch cameras. While they may be used for black-and-white photography, they are designed for color work. They are usually made in focal lengths from 120 mm and to 12.5 mm and can produce magnifications on 35 mm film from 3.2:1 to as high as 40:1 and on 4 x 5-inch film from 5:1 to 60:1! These lenses thus cover the range from close-up to well into photomacrography.

In the last few years, very specialized photographic instruments have been produced that feature zoom optics, electric-drive 35 mm cameras, and totally automated exposure units. These yield high resolution and very precise binocular focusing. While these two options, the specially compounded macro lenses and the zoom macro systems are beyond the requirements or means of most close-up photographers, there is another option which can often be used. It is possible to purchase superb quality lenses originally designed for movie cameras. Mounted either in the normal position or reversed on 35 mm SLR cameras, they will give very fine resolution. With a bellows, magnifications are greater than 1:1.

Controlling the light

DAYLIGHT AND BRIGHTNESS

The preferred illumination for nature and other out-of-door close-ups is certainly sunlight. It is possible to equal the brightness of sunlight with many types of artificial light if the area to be lighted is relatively small and the light source is bright enough.

A Spotted Leaf Beetle is given shape by limiting the subject illumination to 2 flash units at 45 degrees in front and above, thus highlighting one side. The transillumination of the leaves by a third flash unit as a back-light also adds depth and interest to the picture.

All continuous-spectrum light sources (containing amounts of all colors as does daylight, such as tungsten bulbs, electronic flashtubes, flashbulbs, but no fluorescent tubes) have characteristic qualities that can be measured in terms of the color of a theoretically perfect black box radiator heated to a certain temperature and expressed in degrees Kelvin (K). The color of a light source at a high Kelvin temperature is bluish, while that of a light source at a low Kelvin temperature is yellowish.

The brightness of a light source and its color quality or Kelvin temperature are independent factors.

For proper color rendition, the color temperature of the light source must match the requirements of the film being used. Color films balanced for daylight use require a color temperature close to that of natural sunlight (5500 K). Most standard "indoor" or tungsten-balanced color films require a color temperature of at least 3200 K; unfortunately this is hard to match with household bulbs, or even high-intensity reading lamps. Sources commonly used include photofloods at an average of 3200 K, tungsten-halogen lamps (3200 K), or slide projector bulbs at 3350 K. Electronic flash units produce light with a color temperature of 5500 K or the same mix of colors as sunlight.

Tungsten-halogen lamps that project their light through optical fiber bundles or wands are among the very best artificial lights for close-up photographs. Avoid the use of noncontinuous-spectrum sources such as fluorescent lamps which usually emit only certain colors of the spectrum and are deficient in others. If they must be used, make trial exposures and use compensating filters.

As most incandescent bulbs age, the color temperature shifts from a higher to a lower value and the light becomes more yellow. A very old bulb, originally rated at 3450 K, can

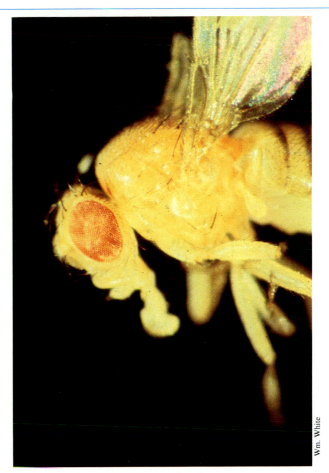

A wild fruit fly, evenly illuminated with direct light to show its pink eye and large proboscis. Lighting consisted of 2 fiberoptic sources, plus daylight. The camera was the WILD-HEERBRUGG M-400, 1/2 aperture at 1/100 sec, on KODAK EKTACHROME 64 Film.

decline to 3050 K with long use.

Many scientific lights and high-intensity lamps are controlled by transformers. The problem with this approach is that as the brightness is reduced, so is the color temperature. The best way to decrease the intensity of light is by moving it farther from the object or with some type of neutral density filter.

When the film is mismatched with the illumination, a characteristic false color cast results. If high color-temperature film intended for outdoor use is used with too low a color-temperature illumination, the result will appear yellow-orange. If lower color-temperature film intended for indoor or artificial light is used with daylight, the result will be much too blue. This, too, can be corrected by using conversion filters, but with loss of film speed due to filter factors.

A Tungsten-Halogen Lamp and Optical Fiber Bundle.

Direct Versus Oblique Lighting

One of the chief constraints of close-up technique is the very restricted depth of field. The sense of depth of field can be increased by careful lighting, but there is a definite choice involved. Direct light is easier and certainly surer of results. In many scientific and technical applications where there must be an exact representation of the subject, direct light is indispensable. However, such photographs have little drama or interest; they lack aesthetic value. For more interesting and arresting images, oblique lighting should be used. Direct light can be produced by photoflood and other standard open bulbs. Oblique light must be contained except for a directed beam. There are many ways that this can be produced. Slide projectors, theatre lights, all manner of small floodlights can be directed through cylinders or cones to produce a narrow beam. The best of these, as previously noted, are the fiber optic systems that can put as much as 250 watts of light directly on a spot as small as 5 mm in diameter.

Transillumination

This is a technique of putting a light behind the subject so that the transparent or translucent features show. This method of lighting for photography has long been used for biological and medical specimens, particularly histological sections. It can also be applied to many other light-transmitting objects. The technique requires a glass plate to hold the subject and some sort of light source beneath. A direct light requires a diffuser below the subject to spread the light. Transillumination can often be combined with oblique lighting to produce very pleasing images.

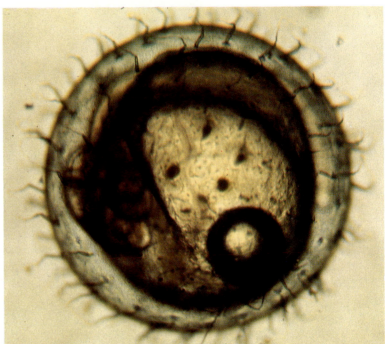

Wm. White

A typical biological slide photo. The developing embryo of a small fresh-water fish, the Japanese Medaka. Taken with the WILD-HEERBRUGG *M-400 Camera, 1/2 aperture at 1/10 second, with a polarizer to eliminate reflections from the water surface. Fiber optics transilluminated the subject.*

Glass Support

— Light Source

Mirror

Transillumination.

Diffusion Discs and Cones

Most direct light is too harsh for the subtle tones and textures of small close-up subjects. It is frequently necessary to maintain the brightness and color temperature of the source but to have the light diffused so that it comes from a variety of directions and eliminates harsh shadow lines or fills in hidden areas. A variety of methods can be used. One of the least complicated is to place a series of industrial mirrors around the subject. These small mirrors will diffuse the light as they reflect it back and forth. Another method is to use a three-point light or a multipoint light. This is especially important in photographing highly reflective metal parts, crystals, and gems. Diffusion discs in front of the light sources and boxes or cones made of diffusing materials, usually plastics, can remove the harshness of a direct light and have little effect on the exposure.

Darkfield Illumination

The darkfield technique was discovered over one hundred years ago and appears in many early books on microbiology and anatomy. While it was introduced as a technique in photomicrography (photography with the compound microscope) to better show translucent specimens, it can also be accomplished in close-up photography. It requires a supporting glass plate as with transillumination; however, the area immediately behind the specimen is kept totally dark. The light enters obliquely from below and to the side. The subject itself "scatters" the light, making it look bright or self-luminous against a dark background. The most difficult part of the technique is the proper calculation of the exposure. The only method which works, aside from trial and error, is to carefully measure the light at the actual image with a meter that can measure a restricted spot. Once a set of exposure data has been proven

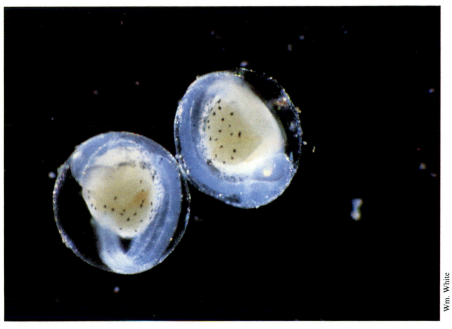

These two fish embryos, developing within their transparent cases, make a better photograph than just one. Note that they are placed in an angle across the frame, to add visual interest. Taken with the WILD-HEERBRUGG M-400 Camera, dark field, 1/2 aperture at 1/30 sec for a 1:1 magnification, on KODAK EKTACHROME 160 Film (Tungsten). Reproduced here at 3.6 ×.

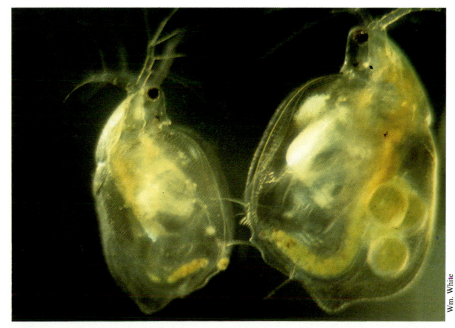

This is one of my all-time favorite photos. It shows two pregnant Daphnia Pulex, or water fleas. It was taken with a reversed MICRO-NIKKOR lens at 1/15 sec with an effective aperture of f/9 and a 3X magnification. The pseudo-darkfield lighting was accomplished with fiber-optic lights. Reproduced here at 10.8X.

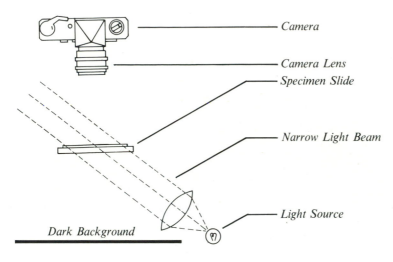

Camera

Camera Lens

Specimen Slide

Narrow Light Beam

Light Source

Dark Background

Darkfield Illumination.

On-Camera Flash.

A Ring Flash Unit.

to work, it will be applicable in most cases. It is with the darkfield technique that the more complex and specialized photomacrographic instruments work the best. But that is no reason the technique cannot be successfully attempted by the nonspecialist close-up photographer. The technique will produce dramatic results with many kinds of subjects. With sufficient practice, they can be photographed as though suspended in space with no visible support.

Flash

For many, many close-up applications, compact electronic flash units are the best sources of light. Since one flash unit will cause too harsh a light

from one direction, it is usually best to use at least two units. One flash should be mounted away from the camera body if at all possible. They usually work best at about twice the distance that the front element of the lens is from the subject.

For many applications and especially for shadowless illumination in science and industry, a ring flash is quite useful. A special adaptation of the ring-flash system is the so-called "medical lens" of which several models are now on the market.

The usual duration of the flash in compact electronic units is $1/1000$ to $1/3000$ of a second. Larger, more specialized units such as those used in industrial testing often can have speeds

of $1/30,000$ to $1/50,000$ of a second. Automatic flash units have a variable flash duration.

There are a number of formulae for calculating the various numerical relationships in close-up flash photography. One that works quite well with the compact flash units usually associated with 35 mm SLR cameras and macro lenses is:

$$D_{fo} = \frac{GN/2}{E_f}$$

where D_{fo} = the distance between the flash unit and the object

GN = Guide Number; this is often in feet and must be converted to inches or centimetres for application to close-up

E_f = the Effective aperture, which is found by the formula: Marked Aperture (*f*-stop) x (Magnification + 1)

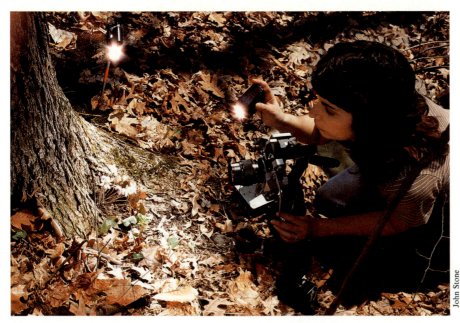

John Stone

Photographing in the field. A tiny subject is lighted with multiple flash units. See the photos on the next page.

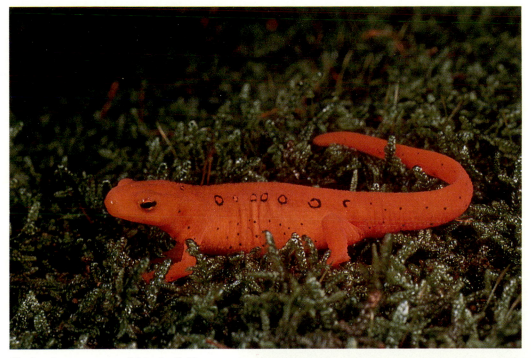

Flash units are very useful in the field. They can freeze the action of natural phenomena and give depth of field that is unattainable with natural light.

This newt (top) is 2 to 3 inches long and turns brownish green when frightened, so it has to be approached with care. It also tends to run very rapidly, so a quick trigger-finger is needed to capture its picture.

The Horn of Plenty trio (right) are very dark, textured mushrooms. They absorb a lot of light and required additional exposure, accomplished by moving the three flash units closer than the usual 12-14 inches. Also, to light the inside of the larger specimen, one flash unit was positioned higher than normal.

For example, let us consider a flash unit with a guide number of 100 used with an *f*-stop of 8 and a magnification of 5 × . In that case, 8 x (5 + 1) =

$$48 \text{ and } \frac{100/_2}{48} = 1.04 \text{ ft}$$ Thus, the

flash unit must be 1.04 ft from the object.

Flash units are very useful in field photography. They can often help to freeze the action of natural phenomena where shutter speed would otherwise be too slow to do so. But with the capacity of flash, care must be taken to control one's exuberance and avoid creating light-blasted photos

Filters and Effects

Filters are often used for two purposes: to correct for color or shading balance with certain films and to add some specific effects such as color backgrounds, multiple images, other novelties. Filtering can play an important part in all lighting situations and is actually required with some light source/film combinations. Novelty filters rarely work well in close-up situations. They often require framing and composition situations which are rarely available in close-up photography. With many types of lamps used in close-up photography, filters are necessary to achieve correct color balance on the film.

Two kinds of filters are often used to improve the image. They are polarizing filters and skylight filters. However, both add more glass in front of the lens and, therefore, have some optical effect. For this reason, you should focus the camera with the filter in place. Typically, glass filters are about 2.5 mm in thickness and they will add a slight aberration at the edges of the frame with highly curved lenses such as wide-angles used in the close-up mode. Compensation for the filter must be calculated in any careful consideration of the exposure. Polarizers add 1 to 2 full aperture stops to the exposure so that the already significant EIF may be aggravated by their use. However, they are necessary with many scenes where light is reflected from liquid or shiny surfaces and obscures the object. Standard data on the use of other filters and their effects appear in many tables and charts.

Tom Carroll

Not exactly a filter, but a unique close-up effect. The photographer placed the 20 mm lens on the eyepiece of an aerial map comparator, which uses red and cyan images to create a 3-dimensional effect. Part of the lens also recorded the barrel of the com- *parator and the actual map itself. Exposed at 1/30 sec at f/5.6, with a CC30M filter to correct for the light source.*

Client: IBM Corporate Advertising.

Filter Effects: A polarizing filter over the lens of the camera was used to eliminate stray reflections from the surface of the pool in this picture of feeding Japanese Koi (hybred carp). One fish actually has its head out of the water, reaching for the food pellets scattered by the photographer.

which look like no natural scenes. The effort should always be aimed at using the capacity of the flash in such a way that the scene, other than an obvious night shot, looks natural with the sun filtering through the trees and with some background tones.

Subject position and support

To get the best results from close-up technique, you must put as much time, effort, and planning into the placing of the subject as into all of the functions of the camera and lens system, film, and the lighting arrangements.

Planning close-ups of mobile objects involves catching the subject in the plane of prime focus and effectively stopping motion with high shutter speed or high-speed flash. This green tree frog was photographed in the Florida Everglades with a 100 mm f/4 macro lens at a magnification of approximately 1:2 and reproduced here at 4X. The lens aperture was f/16 and an electronic flash unit was above the camera and 10 inches from the subject.

The planning and building of sets takes more time than the photography in those studios where close-ups are taken for use as special effects in movies and television. One of the most fascinating parts of close-up technique and one of the most enjoyable is using all of your skills and ingenuity to design, arrange, control, and light the kinds of scenes that make such incredible close-up photographs.

Static Versus Mobile

The preparations for taking close-ups of static subjects—miniature art pieces, coins, stamps, gems, industrial components, or medical devices—is basically one of supplying shadow or tonality to compensate for the shallow depth of field, and at the same time, controlling reflections and "hotspots" where excess light is reflected back into the camera lens. Planning close-ups of mobile subjects, whether they are living organisms or moving machine parts, involves catching the subject in the plane of prime focus and effectively stopping motion with high shutter speed or high-speed flash. This can often be done by carefully timing the shutter release with the arrival of the subject at the predetermined spot. This will not work in many cases, sometimes for no other reason than the "moment of blindness" introduced by the functioning of the SLR camera. Fortunately, there are many types of remote electro-optical or electromechanical shutter controls on the market. They range from infrared and light-sensitive switches to sound-activated systems. These may be coupled to passive night vision instruments and macro lenses. Devices have been contrived to photograph practically any biological or industrial phenomena irrespective of light conditions or organism behavior.

© Bruce Darrell Thomas

Electronic flash, positioned well away from the camera, captured this praying mantis in an embarrassing situation, standing out in contrasting color against red sumac foliage. Taken with a 35 mm camera and 100 mm macro lens and exposed at 1/60 sec at f/22 using 2 flash units, as main and fill lights.

© Vince Streano

Scales and References

In many types of close-ups, reference scales are necessary. These can be unobstrusive, familiar objects such as a coin, a hand holding the item, or a pencil. Where direct measurements are needed, use a light-colored rule with a black number printed on it. Plastic rules or scales on stick-on tapes can be placed with the subject. Scales serve two purposes. They assure the quick comprehension of the scale of magnification without having to print it in the caption. They allow comparison of one subject scale to another. Since close-up photographs sometimes emphasize unusual features or textures of familiar objects, the objects themselves can be hard to identify from everyday experience. Unless you are purposely trying to provide a set of visual puzzles for your viewers, you should avoid this. One way is by making several exposures, each at an increased magnification, from the familiar-size relationship of our experience down to the size of the feature to be shown. The series can be shown sequentially or combined as multiple insets. The method can be done as a montage or later through slide copying techniques.

Making close-ups of static objects is basically a problem of supplying increased tonality to compensate for the shallow depth of field, and at the same time, controlling reflections and hot spots where excess light is reflected back into the lens. Here the photographer has successfully accomplished his task. The radiator temperature gauge of the antique

SEAGRAVE Pumper is nicely shadowed to prevent flare and the open hood components add the needed contrast to the out-of-focus background. Note the various circles of confusion at different degrees of focus.

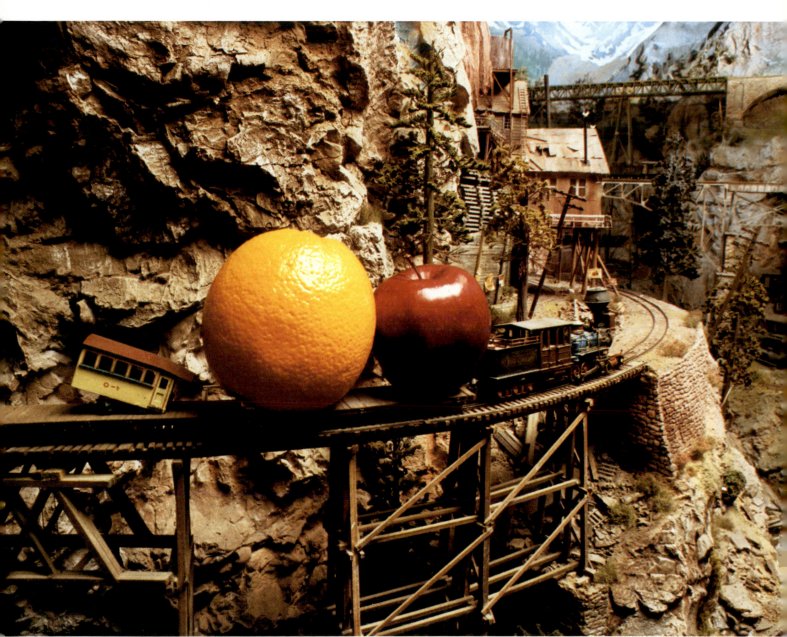

Malcolm Furlow

In some instances, the introduction of familiar objects into a close-up scene, as size references, can be unsettling. The photographer placed an apple and an orange on a scale model flatcar, thus producing, not a size reference, but the largest fruit in the world! The perfect modeling of the set causes one to accept it as being real and to reject the out-of-scale reference items as a visual trick.

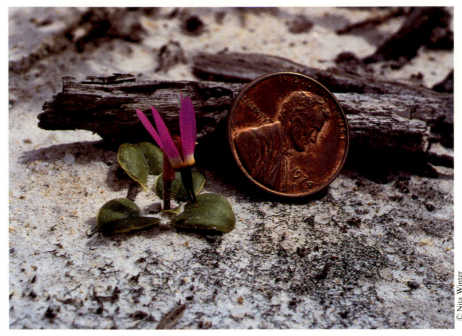

The tiny size of these flowers is instantly realized by comparison with the penny. The flower is a Shooting Star and was photographed in a pygmy forest in Mendocino County, California on a bright overcast day. The camera was positioned flat on the ground, with the photographer likewise.

© Nita Winter

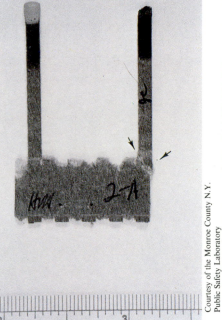

Courtesy of the Monroe County N.Y. Public Safety Laboratory

Comparison Photomacrograph:

A loose, burned paper match from the "Scene" aligned with a matchbook stub from the suspect. The negative was made with an MP-4 Copy Camera and a 135 mm lens. The print was made to a scale of 2 7/8 ×.

The use of arrows to indicate the point of perfect alignment of the match to the stub is quite necessary in this case.

Measurement

Demonstrating a precise measurement is very difficult unless the measuring instrument scales are either put directly on the film with a data back or carefully introduced into the scene when the exposure is made. If placed into the scene, then the measuring device must have the scale in the exact plane of focus of the subject or the specific feature being shown.

It is very rare that a photo editor publishes a photograph exactly the size he received it from the photographer. It is usually desirable to have an idea of the magnification. The simplest way to write this is as the whole number with or without decimal followed by the symbol " × ." This form leads to less confusion than any other and is most easily understood for degree or enlargement. Thus, a 5:1 image-to-object ratio should appear as 5× and an 8.2:1 ratio as 8.2×.

Increase in size: increase in coinage. A fossil trilobite is compared to a quarter. On KODACHROME 25 *Film.*

Allan Horvath

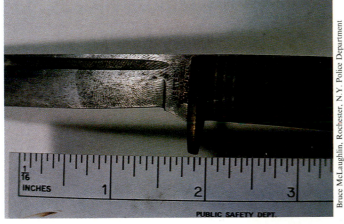

Bruce McLaughlin, Rochester, N.Y. Police Department

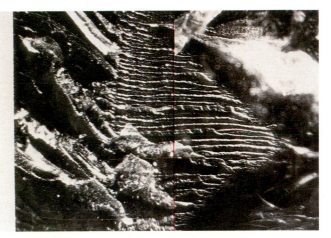

Taken with a 35 mm SLR and 70-210 mm macro-zoom lens, at 1/30 sec, f/11. Two 150-watt photoflood lamps were positioned just to the left of the camera. A KODAK WRATTEN No. 80B Conversion Filter was used to balance the color temperature of the light to the daylight-balanced film. The knife blade was angled to reflect the lights so that the fingerprint, dusted with FAUROT BANTA Gray Fingerprint Powder, would stand out from the corroded blade surface.

This is one of those exceptions to the basic rule "expose for the shadows." In this case, we expose for the highlights so that the flare will not obscure the detail of the powder-darkened fingerprint image. The powder will go black, making it easier to compare the image with existing identified prints.

Comparison Photomicrograph: Photo showing the matching hackle marks from plastic pieces.

Left: Clear plastic piece from the "scene."

Right: Plastic headlamp assembly from a 1976 PONTIAC suspect vehicle. (Continuing evidence from the same case as the photo below.) Photographed through a LEITZ Comparison Photomicroscope with a 50 mm lens and printed to a scale of 35.4 ×.

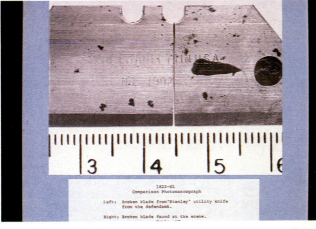

Comparison Photograph:

Left: Broken utility knife blade from the defendant.

Right: Broken blade found at the "Scene." Photo taken with an MP-4 Copy Camera with a 135 mm lens and electronic flash. The print was made to a scale of 4×.

Notice that the position of the scale rule is incontrovertibly close, and in the same plane as the subject.

Harry D. Fraysier, Forensic Chemist
Harvey A. VanHoven, Asst. Forensic Chemist
Courtesy of the Monroe County, N.Y.
Public Safety Laboratory

A plastic headlamp assembly from a 1976 PONTIAC car showing the matching fit of 7 pieces of plastic from the "scene." The negative was made using a CALUMET View Camera with a 165 mm lens on KODAK PLUS-X Pan Professional Film. The print was made to a 1:1 scale.

Courtesy of the Monroe County, N.Y.
Public Safety Laboratory

OBJECTS IN MOTION

Close-up photography of objects in motion is a special subject all its own. There are a number of incredible special-purpose cameras manufactured precisely for this purpose. An SLR camera may not be the best choice in many situations where the "moment of blindness" does not allow for accurate framing. One piece of professional high-speed equipment has a beam-splitter that allows continuous viewing even during the exposure.

Every serious close-up photographer will encounter the need to stop action once in a while. Here are some specific ways that it can be accomplished. Measure carefully the path or line of travel that the subject will take. If it is a wild animal or other living organism, try to confine it as much as possible without hurting or unduly upsetting it. Get some idea of how fast it will be traveling and try to compensate for its movement. Stop the motion with a fast shutter speed or, if that is impossible, use an electronic flash. Keep accurate records of each exposure and your calculations. This will help you to repeat the exposure if successful or to correct it if unsuccessful. W. G. Hyzer, an authority on high-speed photography, suggests the following formula for calculating the exposure time needed to reduce the motion to an acceptable blur in close-up photographs:

$$t = \frac{b}{MV}$$

where t = exposure time in seconds
M = magnification
V = object velocity
b = image blur in mm

For example, if we take an object moving at 10 mm per second at a magnification of 3× and limit the image blur to 0.05 mm, we have t = $\frac{0.05}{10 \times 3}$ = 0.0016 or ¹/₆₀₀ of a second.

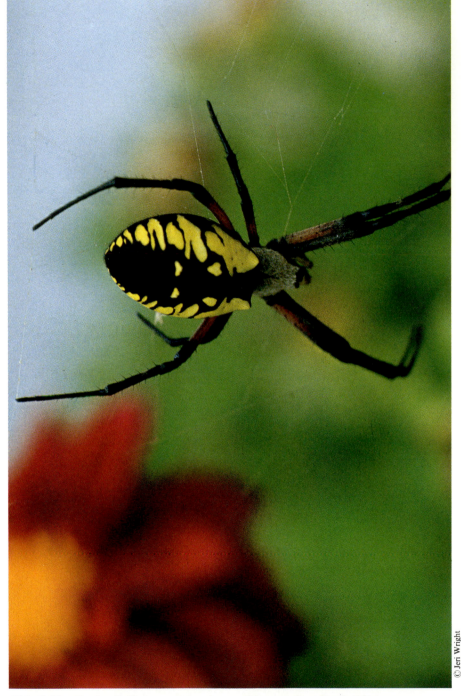

This Golden Garden Spider was captured, in focus, by positioning the camera at a right angle to the plane of the web. Luckily, lateral movement was minimal and stopped by a fast shutter speed. Photographed by early-morning light, with a nearby white building as a reflector, using a 55 mm macro lens, with sufficient depth of field to show a red dahlia in the background. The exposure was 1/125 sec at f/5.6.

Robert Mayers

A fast shutter to stop the action, and the glass wall of the aquarium acting as a depth-of-field limit, captured these fish at the Shedd Aquarium in Chicago. Natural lighting from above with fill-in light from a sandy bottom of the tank.

Both 10 mm per second and 3 × are rather low figures for either the speed of an organism or the magnification often required in close-up techniques. Faster moving objects at the upper range of magnification for close-up photography require specialized equipment and a great deal of expertise. A rule of thumb that will help you to detemine the limits of conventional techniques is that the exposure time must be from three to ten times faster than the duration of the travel across the frame. In other terms, the size of the moving object must be at least three to ten times larger than the blur distance. While they might seem to be an aid, motor-drive SLR cameras may increase the chances of catching the action where it is desired only by a pure hit-or-miss probability.

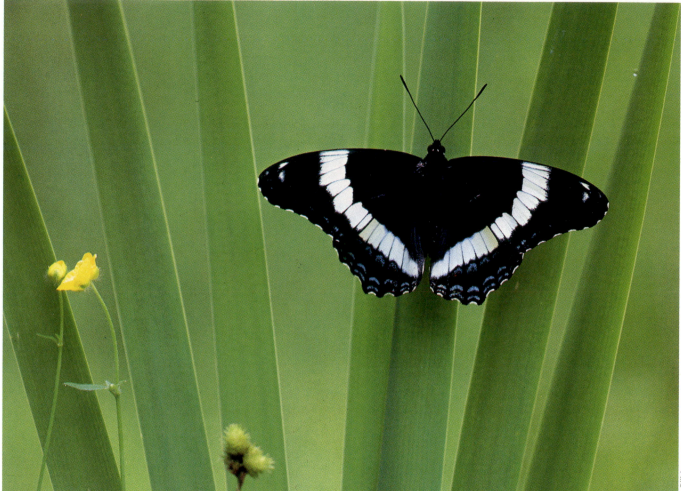

Bill Ivy

Simple Setups

There are some very basic and useful devices that make close-up photography easier. These include:

A set of industrial mirrors for reflecting light from one or two sources onto the subject.

A small turntable, such as a "lazy Susan," for rotating the subject without altering the camera position.

A tabletop jack or set of wooden blocks to raise and lower the subject.

A set of single and double model-maker's clamps and *a locking hemostat.* These allow small objects to be clamped and swung around in any position.

A set of insect pins.

A variety of adhesive materials—clay, SILASTIC Sealing Compound, wax and super glue.

Background materials—poster paper, textiles, and light-absorbers.

A heavy tripod.

A good array of light sources with identifiable color temperatures.

After some experimentation, it will become clear what can be hidden and what can be suggested in close-up photographs. Stands can be suppressed in darkness or deep shadow, or thrown out of focus so severely as to be unrecognizable. Supports can be disguised with a few bits of absorptive

Two simple, but very effective setups. The White Admiral Butterfly (left) resting on cattail leaves contrasts nicely. Notice the balance of the composition with the addition of the tiny yellow blossom.

cloth or neutral colored pieces of paper. It is fairly simple to set up an indoor layout and manipulate all of the variables of the exposure. It is often wise to use a single table as the base of your sets and learn over time what the angles and distances are on its surface. A very good support is a portable vise-top worktable. In such an apparatus, both the camera stand and the subject stand can be clamped at the required distance and elevation. Backgrounds and lights can then be clamped or taped directly to the wooden sideboards of the work area.

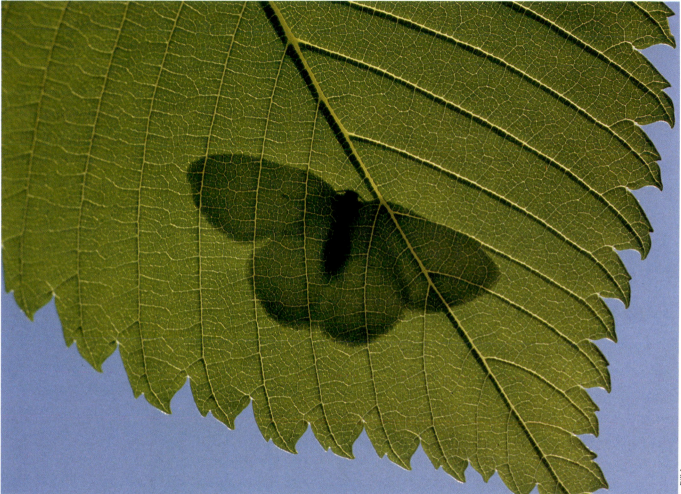

Bill Ivy

The silhouette of the moth (right) on a tree leaf adds delicate emphasis to the pattern of vein detail. Both photographs were taken in an artificial environment set up by the photographer.

Outdoors

The real challenge of close-up photography comes out-of-doors when the control of the variables becomes much more difficult. One who has spent countless hours lying in the mud of a pond with the wind-blown subject and a camera knows about the problems intimately. Success out-of-doors comes directly from a knowledge of the basics of close-up photography and familiarity with the organism or object to be photographed. There may be many hours of study and planning for every hour of photographic activity. You will soon discover that the SLR with a bellows does not work well in the woods or out in the desert. The macro lens with or without the extension ring fitted is usually preferred. Almost any living creature can be photographed with patience and a few small mirrors to direct the sunlight into a burrow or crevice. Where this fails, electronic flash, subtly used, can capture the movement or provide the necessary light where too little exists. For backgrounds, nothing is better than an old wood or stone pile. If you need an instant texture to contrast with the subject, don't be afraid to introduce a bit of bark or to move the scene a few feet one way or the other. Important accessory tools can be a hunting knife and a garden trowel.

Complex Setups

Elaborate close-up sets and complicated lighting arrangements have been devised for commercial science fiction films and the many television specials about the human body and nature subjects. Obviously, you cannot construct the electromechanical controls and servomechanisms involved in such complex projects, but you can build some complex setups with scrap parts and easily available materials.

All complex setups require a properly engineered enclosure that will admit light and suppress reflections. An optical bench, built from a vise-top table or purchased, can be used to align and hold prisms for altering the direction of the light path for reori-

© John Gerlach

The low placement of the flash unit adds dimension to this portrait of a green frog taken in a chest-deep Southern Michigan marsh on a cold day. The frog was reluctant to move because of the temperature, and the photographer was able to get this close-up. Taken at 1/60 sec (synchronization speed) between f/11 and f/16. A portable hot-shoe flash unit was placed to the left of the camera.

Wm. White

This spider egg case was moved to a darkfield background and lighted obliquely with a prism to build contrast in the developing eggs and their silky white covering. Taken with the WILD-HEERBRUGG M-400 Camera, 1/2 aperture, 1/70 sec, at a 4 × magnification. Reproduced here at 17.2 ×.

enting the image as required.

Stop-action photographic setups in industry are largely involved with a sequence of strobe lights and their synchronous pulses with a high-speed camera shutter. Total systems can be bought off the shelf for such applications. But stop-action setups for organisms are much more difficult and specific. A sketch of the axis to be traveled by the organisms, or at least a probability of that axis, is a starting point. To capture life cycles or specific behaviors adequately may involve building a whole habitat in miniature with photographic ports and lighting systems within it. Carefully calibrated electronic flash units and fiber optics may be required. Some organisms, particularly cold-blooded species (poilikotherms), can often be mildly cooled to slow them down. Microorganisms can almost always be slowed by use of a harmless chemical substance which either increases the viscosity of their liquid media or simply anesthetizes them.

Birds and small mammals can usually be photographed with telephoto lenses or automatic shutter tripping devices better than with close-up techniques. Large telephoto lenses with bellows can provide sufficient magnification to fill the frame.

Many types of subjects cannot be removed from liquid immersion to be photographed. Complex setups featuring built-in polarizers and depolarizers or glass tanks with special optically-flat ports are often necessary for photography. The vessels used for inverted microscopes work very well for close-ups in liquid. The optical refractive characteristics of the medium can often be changed; water can be mixed with mineral oil or even salad oil and will provide better light dispersion. Diffuse and fairly subdued lighting works best in such situations. If the sample is supported just barely below the surface of the liquid by a block of

A Cyclop with eggs. The action was slowed down with a commercial veterinary anesthetic. Taken with the WILD-HEERBRUGG M-400 Camera 1/50 sec, full aperture for a 5× magnification on KODAK EKTACHROME 160 Film (Tungsten). Reproduced here at 21.5×.

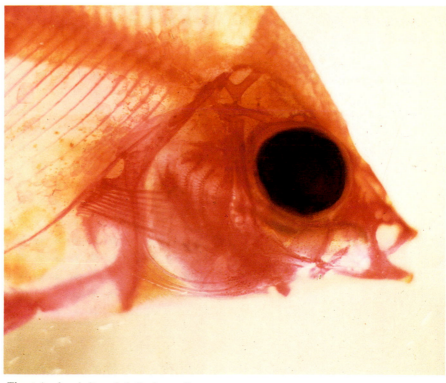

The stained and cleared skull of a small South American fish floating in a 50-percent glycerine and water solution on a plastic spool to allow close-up photography. Taken with a MICRO-NIKKOR lens and bellows, exposure time was 2 sec at an effective aperture of f/45 for a 10X magnification. Reproduced here at 43X.

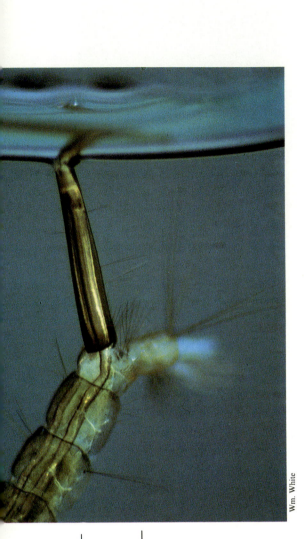

Wm. White

A rather spectacular view of the breathing tube of a mosquito larva as it hangs suspended from the surface tension of the water. The breathing tube can be seen through the transparent body wall all the way to the surface. It was exposed in a micro-aquarium similar to the one shown below. The photographer used a WILD-HEERBRUGG Camera with prisms, and supplementary lenses at full aperture, 1/100 sec, to get this close-up photo, approximately a 15× magnification. Reproduced here at 64.5×.

quartz or translucent plastic, the specimen can be lighted and kept in focus and the block will not show.

Table of Refractive Indices

Water	1.33
Glycerin and	
Water 50%/50%	1.40
Glycerine	1.45
m-Xylene	1.49
Cedar oil	1.51
Standard Immersion oil	1.51
Clove oil	1.51

For close-up photography through the side of a container, the construction material should be as thin as possible. The photographic port must be as flat as possible and can often be a window of much thinner material. Many times the area of activity in which the prime focus falls and where the depth of field will be calculated does not extend far into the container. Organisms can often be induced to stay in a restricted area by the use of a beam of light or a low-voltage electric current. The best approach is to make a microaquarium within a larger chamber or to include a small but

Photomicroscope

Silvered prism

Optical flat

Microaquarium

Wm. White

A special photographic tank for fish, with light baffles in the sides and a dark frame.

transparent holding pen to limit subject movement sufficiently.

Always remember that any optical component that intersects the light path has an effect, no matter how subtle, on the image. It must be compensated for or it will degrade the image. Many times chilling the top of a container or providing a curtain of chilled air or carbon dioxide will keep an organism contained within the prime focus.

THE PROBLEM OF HEAT

The great enemy of many small complex sets is heat from the photo lamps. While quartz-iodine and other types of brilliant lamps can provide the kind of intensity and color temperatures required, they can also melt everything in sight and super heat camera components to a dangerous degree. It is a good practice to have a thermometer or thermocouple connected to a readout device somewhere near the object area. Where photographs are being made of plastic or other synthetic materials, flammable materials, foods or other perishables, good air circulation is important. Cooler modeling lights should be used for routine focus and calculation purposes. Hot lights should only be used for the few seconds it takes to make the actual determination of light levels and to complete the exposure. With live organisms, cooling coils or heat absorbing filters may be placed around the lights. In very critical cases where microcontainers are employed or the immersion liquid is flammable, glass aquaria can be put in front of the lights. In extreme cases, mirrors or prisms on stands can be mounted to reflect sunlight into the object area, thus reducing the potential for heating. A most convenient solution is the use of fiber-optic lights that allow the actual incandescent-bulb to be at a distance. These light delivery wands are completely free of any heat transmission.

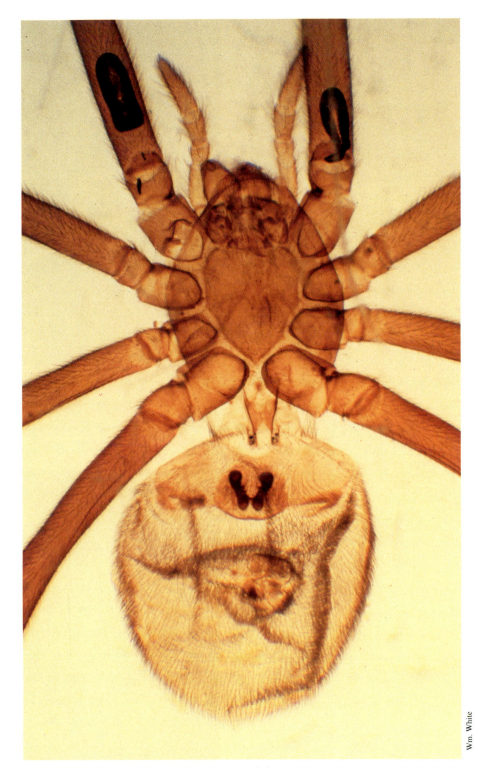

Wm. White

A stained and cleared spider to show the internal organs and structures. Photographed in pure clove oil with the WILD-HEERBRUGG M-400 Camera at *1/2 sec, 1/2 aperture, transmitted light for a 5 × magnification on KODAK EKTACHROME 160 (Tungsten) Film. Reproduced here at 12 ×.*

Jan Hinsch

(A) *This series was made by Jan Hinsch of E. Leitz Corporation, Rockleigh, New Jersey. He capitalized on his son's interest in growing brine shrimp. The eggs were purchased in a pet shop. It shows what minimal equipment and patience can accomplish in close-up photography.*

The LEICA M1 Camera with a mirror-reflex housing, a short-focus lens and supplementary plus extension ring. Note the tiny microaquarium in the stage.

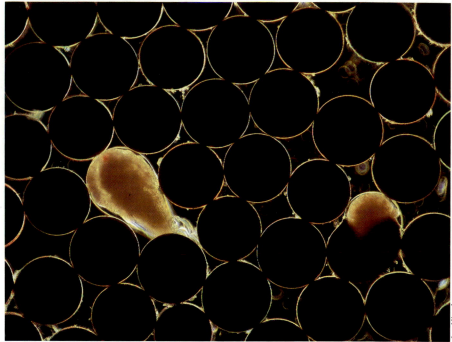

Jan Hinsch

(B) *The black spheres are the shrimp eggs. The yellow objects are the tiny, newborn shrimp. One is actually hatching. These are all 18 × magnifications at the film plane on KODACHROME Film; reproduced here at 72 ×.*

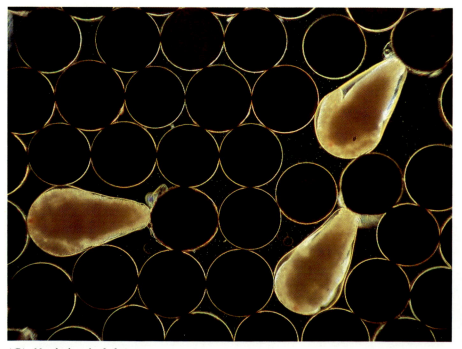

(C) *Newly hatched shrimp.*

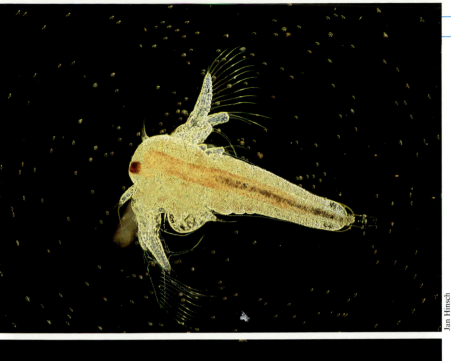

(D) The shrimp are beginning to swim
 about and take on the adult
 body shape.

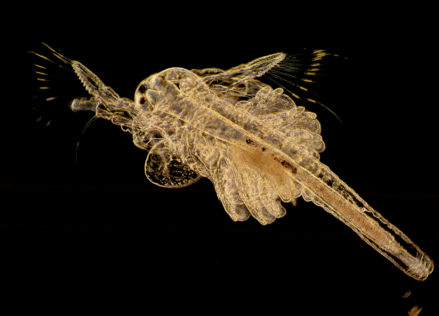

(E) Nearly mature shrimp.

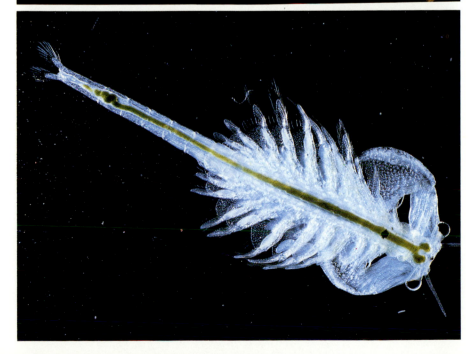

(F) Fully mature male. Note how, in the
 last three photos, the photographer
 placed the subject at the same angle
 in the frame. The use of good
 composition in arranging and
 framing any photograph, no matter
 what size the subject, is almost as
 important as proper exposure. Study
 the rules of design as you study the
 laws of photography; the success of
 your pictures depends upon the
 proper use of both.

83

Close-up applications

There are many applications of the techniques of close-up photography that have become separate endeavors unto themselves. Each of them is worthy of a book of its own, and many are available.

We mention these fields of close-up photography in passing, because they each can provide a lifetime of fascination and livelihood for photographers working in them exclusively.

Copy of a papyrus scroll from Cave 7 at Qumran, the famous Dead Sea Scrolls. The photo was taken with a NIKON Camera and KODAK TRI-X Film pushed to ASA 1600. A rubber lens cap rested against the glass museum case and provided protection to the lens as well as a steady resting place for the camera.

Actual size

Enlargement: 400%

Wm. White

COPYING

Copying is a special application of close-up photography that involves a two-dimensional object. It is one of the easiest of all close-up techniques to utilize. However, it can be varied to provide all kinds of important results. By placing filters in the image path and altering the wavelength of light used, decipherable photographs can be made of ancient documents that are illegible through the action of water, fire, or decay.

In copying with a SLR, the shorter-focus macro lenses of 40 to 60 mm are usually most useful. Often the intent is to reduce a whole page to a 35 mm negative and then to enlarge it for reading. Unlike other close-up applications, it is rarely necessary to enlarge the print beyond or even up to the size of the original. Therefore, you must work from the size of the subject area that will be photographed back to the magnification needed. Since it is usually considerably less than 1:1 or life-size, a macro lens or a normal lens with a short extension tube can accomplish the task with ease. Flash is only required occasionally. The author has toured many of the great libraries of the world, taking books or documents to a sunny window and using daylight color films with great success. It is a good idea to use a rubber sunshade on the camera lens. This can be rested harmlessly on the glass of a museum case while the SLR camera is employed to take a photograph of a rare document. There are a variety of high-speed, high-contrast, black-and-white copy films available for this application.

SLIDE DUPLICATION

Slide duplication is another very special application of close-up technique. There are a number of duplicator attachments available that make 1:1 copying of transparencies a simple task.

A documentation photograph of a failed metal bolt from a nuclear power plant valve. The crystal-like sheer is of prime interest. Diffused and indirect lights were used to decrease the specular reflections and glare. Photographed with the WILD-HEERBRUGG M-400 Camera at 1 sec, 1/20 aperture on KODAK EKTACHROME 160 Film (Tungsten). A 1:1 magnification at the film plane; reproduced here at 2.6 ×.

DOCUMENTATION

In the hospital, the laboratory, the factory, and many other institutions and locations, accurate photographic records of activities are required. Many of these photographs are close-ups and systems must be set up to keep them in order, to document their origin, and to identify the subject for future reference. The use of a data back on the camera with an imprint of date, time, and a sequential number on each frame is a vast time saver. However, no series of transparencies or negatives can be useful as records without a good system for organizing and retrieving them.

RECORD KEEPING

Close-up photographs can be very helpful in assuring the accuracy of inventories for insurance purposes and to deter theft. To be useful, they should include the serial numbers or other identifying marks on the items to be inventoried. For this purpose, fine-grain black-and-white film or color transparency film and the use of a ring-light are the best approach. In most cases it is not necessary to print the negatives. Keep negatives or transparencies in a good, tight container in a cool, dark place such as a safe-deposit box. It is usually not important to have the actual serial num-

Record photographs of a Satsuma wine flacon which was made in the late 18th Century for the Japanese Imperial Family. Much later it was converted into a lamp and at that time the maker's mark was covered with a wooden base. However, because the images of the "Emperor's Children" are so individual, a close-up photo of a happy group serves as a means of positive identification.

ber of all objects on the inventory as many objects simply have none. However, if small scratches or paint streaks can be shown, they can be matched to identify the object, should that need ever arise. The courts and insurance companies usually accept such photographic evidence as positive proof of identification.

FORENSIC PHOTOGRAPHY

Forensic photography is one of the criminal investigator's most important tools. Fine particles of skin, hairs of specific animal species and varieties, and many types of dust and metal fragments can be typed, analyzed, and traced with the use of close-up photography. With the proper combinations of film, filtration, and light sources, many alterations, such as forgeries, illegal entires and replacements, can be detected and photographed with close-up techniques.

Comparison Photomicrograph:

Left: *Material from victim's jacket.*

Right: *Fabric portion removed from hood of suspect's car.*

Photographed by means of a Leitz *Comparison Photomicroscope with a 50 mm lens and lighted with fiber-optic units. Scale is 36×.*

Harry D. Fraysier, Forensic Chemist
Harvey A. Vanhoven, Asst. Forensic Chemist
Courtesy of the Monroe County, N.Y.
Public Safety Laboratory

Comparison Photomacrograph:

Upper piece: *Piece of metal found at the "scene."*

Lower piece: *Headlamp assembly from the suspect vehicle.*

Photographed with an MP-4 Copy Camera with a 135 mm lens using the normal copy lights. A scale of 1:1.

Courtesy of the Monroe County, N.Y.
Public Safety Laboratory

Comparison Photomicrograph:

Left: *Control. Paint from victim's truck (layered red, white, and brown.)*

Right: *Paint chip found on defendant's green car. (Layered red, white, and brown.)*

Photographed with a Leitz *Comparison Photomicroscope with fiber-optic illumination and a 25 mm lens for a scale of magnification of 80×.*

Courtesy of the Monroe County, N.Y.
Public Safety Laboratory.

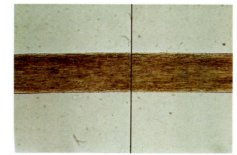

Comparison Photomicrograph:

Left: *Caucasian head hair from window frame at the "scene".*

Right: *Caucasian head hair from the defendant.*

Photographed with a Leitz *Comparison Photomicroscope with a 25× objective. Scale: 250×*

Courtesy of the Monroe County, N.Y.
Public Safety Laboratory

MEDICAL PHOTOGRAPHY

A common object of close-up photography in the medical or biological laboratory is the 1 x 3-inch glass microscope slide with a section of biological tissue or organism mounted on it. These slides are always photographed best by transillumination. It is often not necessary to photograph them through a compound microscope unless some particular feature must be shown in high magnification. A simple glass-covered stand with a single compact flash unit behind it or a light bulb with color temperature controllable to 3200 K will produce good results. Most compound microscopes with rotating turrets regularly carry a low-power scanning objective; the same magnification can be gotten with a macro lens and bellows unit used on an SLR camera.

A series of photographs of the cross-section of a mammalian tongue, H&E stained. The magnifications are marked. The 5X and 10X magnifications are within the capabilities of normal photomacrography, but the greater magnifications are in the realm of photomicrography. This series was photographed through a NIKON BIOPHOT Microscope with PLANAPOCHROMAT and PLANAPOCHROMAT Objectives. The film was push-processed one stop to gain contrast. An exposure series was made at each magnification. Reproduced here at an additional 2X.

For information in detail regarding photomicrography, see KODAK Publication No. P-2, Photography Through the Microscope.

Martin Scott FBPA

5 ×

10 ×

25 ×

50 ×

100 ×

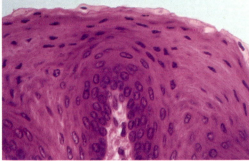

200 ×

500 ×

Films for Close-Up Photography

You can use almost any film type for close-up photography — color, black-and-white, prints, or slides. Which film you choose depends on what you intend to use the pictures for, your shooting conditions, and how the final image should look. High-speed films will often enable you to handhold the camera and use small *f*/stops in existing light. However, they may lack sharpness and definition. Medium- and low-speed films give exceptional sharpness, but for close-up photography they often need to be used with a flash unit and/or camera support.

Because book printers prefer working with slide films, most of the pictures in this book were taken on slide films. Use a slide film if you want to use your photos in a presentation or submit them to magazines for publication. However, you'll probably want to use a color negative film. It gives the best results when you want to make enlargements.

When selecting a film for close-up photography, consider the definition characteristics you want and the film speed appropriate for the lighting conditions. With color film you should match the color balance of the film with the light source, such as daylight film for daylight and electronic flash, and tungsten film for tungsten light. You can also use filters to color-balance the film more closely to the light source. See the film tables that follow.

Definition is the clarity of detail seen when viewing a photograph and is usually described by the degree of graininess, resolving power, and sharpness. Classifications for each of these definition factors have been assigned to Kodak films. Generally speaking, the slower the speed of the film, the higher the definition. The higher the definition, the more able the film is to capture detail. In close-up photography, the objective is to capture detail.

This Indian jewelry was photographed on a slow-speed color negative film in Taos, New Mexico. Photo was taken in the early morning with backlighting. The extreme sharpness and fine grain rendered by this film is evident in this close-up of the jewelry on the hand of this man—the oldest member of the Taos tribe. The jewelry is made by the Indians on the reservation.

Neil Montanus

KODAK Black-and-White Films

KODAK Black-and-White Films	Film Speed		Sizes, Sheet	Definition	
	Daylight	Tungsten		Grain[†]	Resolving Power[‡]
Technical Pan (TP); 2415, 4415, 6415	25*	25*	135, 120, sheet	MF	EH / 320
T-MAX 100 Professional (TMX); sheet 4052	100	100	135, 120, sheet	EF	VH / 200
PLUS-X Pan (PX) / PLUS-X Pan Professional (PXP)	125	125	135, 120, 220	EF	H / 125
PLUS-X Pan Professional 4147 (PXT)	125	125	sheet	VF	H / 125
TRI-X Pan Professional (TXT); sheet 4164	320	320	120, 220, sheet	F	H / 100
TRI-X Pan (TX)	400	400	135, 120	F	H / 100
T-MAX 400 Professional (TMY); sheet 4053	400	400	135, 120, sheet	EF	VH / 125

KODAK Color Print Films

KODAK Color Print Films	Color Balance	ISO Speed and Filter			Sizes, Sheet	Grain[†]	Process
		Daylight	Tungsten (3200 K)	Photolamp (3400 K)			
EKTAR 25 Professional (PHR)	Daylight	25	6 / No. 80A	8 / No. 80B	135, 120	MF	C-41
EKTACOLOR GPF 160 Professional (GPF)	Daylight	160	40 / No. 80A	50 / No. 80B	135	EF	C-41
GOLD 100 (GA)	Daylight	100	25 / No. 80A	32 / No. 80B	135	EF	C-41
GOLD 200 (GB)	Daylight	200	50 / No. 80A	64 / No. 80B	135	EF	C-41
ROYAL GOLD 25 (RZ)	Daylight	25	6 / No. 80A	8 / No. 80B	135	MF	C-41
ROYAL GOLD 100 (RA)	Daylight	100	25 / No. 80A	32 / No. 80B	135	MF	C-41
ROYAL GOLD 200 (RB)	Daylight	200	50 / No. 80A	64 / No. 80B	135	EF	C-41
ROYAL GOLD 400 (RC)	Daylight	400	100 / No. 80A	125 / No. 80B	135	EF	C-41

KODAK Color Slide Films

KODAK Color Slide Films	Color Balance	ISO Speed and Filter			Sizes, Sheet	Grain[†]	Process
		Daylight	Tungsten (3200 K)	Photolamp (3400 K)			
KODACHROME 25 (KM & PKM)	Daylight	25	6 / No. 80A	8 / No. 80B	135	EF	K-14
KODACHROME 64 (KR & PKR)	Daylight	64	16 / No. 80A	20 / No. 80B	135	EF	K-14
KODACHROME 200 (KL & PKL)	Daylight	200	50 / No. 80A	64 / No. 80B	135	F	K-14
KODACHROME 40 Type A (KPA)	Photolamp	25 / No. 85	32 / No. 82A	40	135	EF	K-14
EKTACHROME 64 Professional 5017, 6017 (EPR); sheet 6117	Daylight	64	16 / No. 80A	20 / No. 80B	135, 120, 220, sheet	VF	E-6
EKTACHROME 100 Professional 5058, 6058 (EPN); sheet 7058	Daylight	100	25 / No. 80A	32 / No. 80B	135, 120, 220, sheet	VF	E-6
EKTACHROME 100 PLUS Professional (EPP)	Daylight	100	25 / No. 80A	32 / No. 80B	135, 120, 220, sheet	VF	E-6
EKTACHROME 64X Professional (EPX)	Daylight	64	16 / No. 80A	20 / No. 80B	135, 120	VF	E-6
EKTACHROME 100X Professional (EPZ)	Daylight	100	25 / No. 80A	32 / No. 80B	135, 120, sheet	VF	E-6
EKTACHROME 64T Professional (EPY)	Tungsten	40 / No. 85B	64	50 / No. 81A	135, 120, sheet	VF	E-6
EKTACHROME 160T (ET & EPT)	Tungsten	100 / No. 85B	160	125 / No. 81A	135, 120	VF	E-6
EKTACHROME LUMIERE 100 Professional (LPP)	Daylight	100	25 / No. 80A	32 / No. 80B	135, 120, sheet	EF	E-6
EKTACHROME LUMIERE 100X Professional (LPZ)	Daylight	100	25 / No. 80A	32 / No. 80B	135, 120, 220	EF	E-6

* Speed with KODAK TECHNIDOL Liquid Developer.

† Grain:
MF—Micro-Fine
EF—Extremely Fine
VF—Very Fine
F—Fine

‡ Resolving Power; lines per mm:
EH—Extremely High
VH—Very High
H—High

Charts and graphs

Depth of Field (reference page 26, 51)

Formula: $d = \dfrac{2fc\,(m + 1)}{m^2}$

d = depth of field
m = magnification
f = aperture
c = circle of confusion (0.033 mm)

DEPTH OF FIELD IN mm

| | | \multicolumn{20}{c}{Magnification} |
|---|---|

Aperture		0.2	0.4	0.6	0.8	1.0	1.2	1.4	1.6	1.8	2.0	2.2	2.4	2.6	2.8	3.0	3.2	3.4	3.6	3.8	4.0
	$f/8$	15.84	4.62	2.35	1.48	1.06	0.80	0.64	0.54	0.46	0.40	0.35	0.31	0.28	0.26	0.23	0.22	0.20	.187	.175	.165
	$f/11$	21.78	6.35	3.23	2.04	1.45	1.11	0.89	0.74	0.63	0.54	0.48	0.43	0.39	0.35	0.32	0.30	0.28	0.26	.241	.227
	$f/16$	31.68	9.24	4.69	2.97	2.11	1.61	1.29	1.07	0.91	0.79	0.70	0.62	0.56	0.51	0.47	0.43	0.40	.375	.351	.330

At magnifications above 1:1, the depth of field, (the part of the subject that appears to be sharp from nearest to farthest from the camera) is evenly divided on both sides of the plane of critical focus.

Exposure Increase Factors (reference page 27, 28)

Formula: $EIF = (m + 1)^2$

EIF = Exposure increase factor
m = magnification

EXPOSURE INCREASE FACTOR AND APERTURE COMPENSATION

| | \multicolumn{20}{c}{Magnification} |
|---|

	0.2	0.4	0.6	0.8	1.0	1.2	1.4	1.6	1.8	2.0	2.2	2.4	2.6	2.8	3.0	3.2	3.4	3.6	3.8	4.0
Exposure Increase	1.44	1.96	2.56	3.24	4.00	4.84	5.76	6.76	7.84	9.00	10.24	11.56	12.96	14.44	16.00	17.64	19.36	21.16	23.04	25.00
f-stop correction	1/2	1	1 1/4	1 3/4	2	2 1/4	2 1/2	2 3/4	3	3 1/4	3 1/4	3 1/2	3 3/4	3 3/4	4	4 1/4	4 1/4	4 1/2	4 1/2	4 3/4

To determine the proper exposure at increased magnifications *either* multiply the exposure time by the given fraction *or* open the f-stop setting by the given amount.

Exposure Increase Factors (reference page 28)

Formula: $EIF = \dfrac{V^2}{F^2}$

EIF = exposure increase factor
V = distance from lens diaphragm to film plane
F = focal length of lens (at infinity)

LENS DIAPHRAGM—FILM PLANE DISTANCE (mm)

Focal Length of Lens (mm)	30	40	50	60	70	80	90	100	200	300	400	500	600	700	800	900	1000	1100	1200	1300	1400	1500	1600	1700	1800	1900
28	1.15	2.04	3.19	4.59	6.25	8.16	10.33	12.76	51.02	114.80	204.08	318.87	495.18													
35		1.31	2.04	2.94	4.0	5.22	6.61	8.16	32.65	73.47	130.61	204.08	293.88													
55				1.19	1.62	2.12	2.68	3.31	13.22	29.76	52.90	82.64	119.0													
80							1.27	1.56	6.25	14.06	25.0	39.06	56.25													
105									3.63	8.16	14.51	22.68	32.66													
135									2.19	4.94	8.78	13.71	19.75	26.89	35.11	44.44	54.87	66.40	79.01	92.73	107.54	123.46	140.47	158.57	177.77	198.07
170									1.38	3.11	5.54	8.65	12.46	16.96	22.15	28.02	34.60	41.87	49.83	58.48	67.82	77.85	88.58	100.0	112.11	124.91
250										1.44	2.56	4.0	5.76	7.84	10.24	12.96	16.0	19.36	23.04	27.04	31.36	36.0	40.96	46.24	51.84	57.76
500													1.44	1.96	2.56	3.24	4.0	4.84	5.76	6.76	7.84	9.0	10.24	11.56	12.96	14.44

Extension Tube and Bellows Distance (reference page 42, 50, 51)

Formula: d = F x m

d = distance in mm of extension
F = focal length of lens
m = magnification desired

MAGNIFICATION

Focal Length of Lens (mm)	0.5	1.0	1.2	1.4	1.6	1.8	2.0	2.2	2.4	2.6	2.8	3.0	3.2	3.4	3.6	3.8	4.0	5.0	6.0	7.0	8.0	9.0	10.0
28	14	28	33.6	39.2	44.8	50.4	56	61.6	67.2	72.8	78.4	84	89.6	95.2	100.8	106	112	140	168	196	224	252	280
35	17.5	35	42	49	56	63	70	77	84	91	98	105	112	119	126	133	140	175	210	245	280	315	350
55	27.5	55	66	77	88	99	110	121	132	143	154	165	176	187	198	209	220	275	330	385	440	495	550
80	40	80	96	112	128	144	160	176	192	208	224	240	256	272	288	304	320	400	480	560	640	720	800
105	52.5	105	126	147	168	189	210	231	252	273	294	315	336	357	378	399	420	525	630	735	840	945	1050
135	67.5	135	162	189	216	243	270	297	324	351	378	405	432	459	486	513	540	675	810	945	1080	1215	1350
170	85	170	204	238	272	306	340	374	408	442	476	510	544	578	612	646	680	850	1020	1190	1360	1530	1700
250	125	250	300	350	400	450	500	550	600	650	700	750	800	850	900	950	1000	1250	1500	1750	2000	250	2500
500	250	500	600	700	800	900	1000	1100	1200	1300	1400	1500	1600	1700	1800	1900	2000	2500	3000	3500	4000	4500	5000

**Typical Extension Tubes Used with a 50 mm Lens on
a 35 mm Camera Focused at Infinity (reference page 51)**

Tube Length (millimetres)	Approximate Magnification	Approximate Exposure Factor
Set #1		
12	.24	1.5
20	.40	2
12 + 20	.64	2.7
36	.72	3
12 + 36	.96	3.9
20 + 36	1.12	4.5
12 + 20 + 36	1.36	5.6
Set #2		
9.5	.19	1.4
19	.38	1.9
28.5	.57	2.5
9.5 + 28.5	.76	3.1
19 + 28.5	.95	3.8
9.5 + 19 + 28.5	1.14	4.6

†Based on an image size of 22.8 x 34.2 mm, which is 95 percent of nominal 24 x 36 mm frame dimensions.

Supplementary Lens charts (reference page 50–52)

SUPPLEMENTARY LENSES*

Close-up Lens	Focus Setting		Lens-to-Subject Distance†		Approximate Field Size 50 mm Lens	
	(metres)	(feet)	(mm)	(in.)	(mm)	(in.)
+1	∞	∞	1000	39 3/8	456 x 684	18 x 27
	4.5	15	818	32 1/4	373 x 560	14 5/8 x 22
	1.8	6	642	25 3/8	293 x 439	11 1/2 x 17 1/4
	1.1	3 1/2	524	20 5/8	239 x 358	9 3/8 x 14 1/8
+2	∞	∞	500	19 5/8	228 x 342	9 x 13 1/2
	4.5	15	450	17 3/4	205 x 308	8 1/2 x 12 1/8
	1.8	6	391	15 3/8	178 x 267	7 x 10 1/2
	1.1	3 1/2	344	13 1/2	157 x 235	6 1/8 x 9 1/4
+3	∞	∞	333	13 1/8	152 x 228	6 x 9
	4.5	15	310	12 1/4	141 x 212	5 1/2 x 8 3/8
	1.8	6	281	11 1/8	128 x 192	5 x 7 1/2
	1.1	3 1/2	256	10	117 x 175	4 5/8 x 6 7/8
+4	∞	∞	250	9 7/8	114 x 171	4 1/2 x 6 3/4
	4.5	15	237	9 3/8	108 x 162	4 1/4 x 6 3/8
	1.8	6	219	8 5/8	100 x 150	4 x 5 7/8
	1.1	3 1/2	204	8	93 x 140	3 5/8 x 5 1/2
+5	∞	∞	200	7 7/8	91 x 137	3 5/8 x 5 3/8
	4.5	15	191	7 1/2	87 x 131	3 5/8 x 5 1/8
	1.8	6	180	7 1/8	82 x 123	3 1/4 x 4 7/8
	1.1	3 1/2	169	6 5/8	77 x 116	3 x 4 5/8
+6	∞	∞	167	6 1/2	76 x 114	3 x 4 1/2
	4.5	15	161	6 3/8	73 x 110	2 7/8 x 4 3/8
	1.8	6	153	6	70 x 105	2 3/4 x 4 1/8
	1.1	3 1/2	145	5 3/4	66 x 99	2 5/8 x 3 7/8

*Calculations are based on the definition of *diopter,* i.e., the reciprocal of the lens focal length in *metres.* Therefore, metric measurement is primary.

†Lens-to-subject distances apply to close-up lens used with any camera lens. Field size applies only to use with 50 mm lens. It is based on a film dimension of 22.8 x 34.2 mm which is 95 percent of the 24 x 36 mm camera frame.

	Depth of Field at *f*/8 with Supplementary Lenses on a 35 mm Camera with a 50 mm Lens at Infinity Focus*					
Diopters	Near		Far		Total	
	(inches)	(millimetres)	(inches)	(millimetres)	(inches)	(millimetres)
+1	5 1/4	133	7 3/8	187	12 5/8	320
+2	1 1/2	38	1 3/4	44	3 1/4	82
+3	5/8	16	3/4	19	1 3/8	35
+4	3/8	9	1/2	13	7/8	22
+5	1/4	6	1/4	6	1/2	12
+6	1/8	3	1/4	6	3/8	9

*At a 3-foot (1 metre) focus setting, depth figures are close to those for infinity focus with a supplementary lens of the next higher power.

KODAK Professional Black-and-White Films—Reciprocity Effect Adjustments

EKTAPAN 4162†
 (ESTAR Thick Base)
PLUS-X Pan
PLUS-X Pan Professional 2147
 (ESTAR Base)

PLUS-X Pan Professional 4147
 (ESTAR Thick Base)
TRI-X Pan
TRI-X Pan Professional 4164‡
 (ESTAR Thick Base)

BLACK-AND-WHITE FILMS RECIPROCITY CORRECTION TABLE

	Exposure Time (seconds)*					
	1/100,000	1/10,000	1/1,000	1	10	100
Conventional Films (see above)						
Adjust Lens Aperture (f-stop) or	+1	+1/2	None	+1	+2	+3
Adjust Exposure Time (seconds)	Change aperture	Change aperture	None	2	50	1200
Adjust Development	+20%	+15%	+10%	−10%	−20%	−30%
T-MAX 100 Professional Film						
Adjust Lens Aperture (f-stop) or	—	+1/3	None	+1/3	+1/2	+1
Adjust Exposure Time (seconds)	—	None	None	None	15	200
No development adjustment required						
T-MAX 400 Professional Film						
Adjust Lens Aperture (f-stop) or	—	None	None	+1/3	+1/2	+1 1/2
Adjust Exposure Time (seconds)	—	None	None	None	15	300
No development adjustment required						

*No exposure time required for 1/100 and 1/10.
†Data for 1/10,000 and 1/100,000 second does not apply.
‡Data for 1/100,000 second does not apply.

NOTICE: The reciprocity data in this publication are representative of production coatings and, therefore, do not apply directly to a particular box or roll of photographic material. They do not represent standards which must be met by Eastman Kodak Company. The company reserves the right to change and improve products at any time.

For critical use, a confirming photographic test should be made on film of the same emulsion number as that to be used for the final exposure. The emulsion number is stamped on each film box.

KODAK Color Print Films	Reciprocity Characteristics Exposure* Compensation and Filter					
	1/10,000	1/1000 / 1/100	1/10	1	10	100
EKTAR 25 Professional (PHR)	None / No Filter					
EKTACOLOR GPF 160 Professional (GPF)	None / No Filter			+1 stop / CC20Y	NR	
GOLD 100 (GA)	None / No Filter					NR
GOLD 200 (GB)	None / No Filter					NR
ROYAL GOLD 25 (RZ)	None / No Filter					
ROYAL GOLD 100 (RA)	None / No Filter					NR
ROYAL GOLD 200 (RB)	None / No Filter					NR
ROYAL GOLD 400 (RC)	None / No Filter					NR

KODAK Color Slide Films	Reciprocity Characteristics Exposure* Compensation and Filter					
	1/10,000†	1/1000† / 1/100	1/10	1	10	100
KODACHROME 25 (Daylight) (KM & PKM)	None / No Filter			+$\frac{1}{2}$ stop / No Filter	NR	
KODACHROME 64 (Daylight) (KR & PKR)	None / No Filter		+$\frac{1}{3}$ stop / CC05R	NR		
KODACHROME 200 (Daylight) (KL & PKL)	None / No Filter			+$\frac{1}{2}$ stop / CC10Y	NR	
KODACHROME 40 Type A (KPA)	None / No Filter			+$\frac{1}{2}$ stop / CC05R	NR	
EKTACHROME 64 Professional 5017, 6017 (Daylight) (EPR); sheet 6117	None / No Filter			+$\frac{1}{3}$ stop / CC05R	NR	
EKTACHROME 100 Professional 5058, 6058 (Daylight) (EPN); sheet 7058	None / No Filter			+$\frac{1}{3}$ stop / CC05M	NR	
EKTACHROME 100 PLUS Professional (Daylight) (EPP)	None / No Filter			+$\frac{1}{3}$ stop / CC05R	NR	
EKTACHROME 64X Professional (Daylight) (EPX)	None / No Filter			+$\frac{1}{3}$ stop / CC05R	NR	
EKTACHROME 100X Professional (Daylight) (EPZ)	None / No Filter			+$\frac{1}{3}$ stop / CC05R	NR	
EKTACHROME 64T Professional (Tungsten) (EPY)	None / No Filter					+$\frac{1}{3}$ stop / CC05R
EKTACHROME 160T (Tungsten) (ET & EPT)	None / No Filter			+$\frac{1}{3}$ stop / CC10R	NR	
EKTACHROME LUMIERE 100 Professional (LPP)	CC05Y	None / No Filter		+$\frac{1}{2}$ stop / CC05B		NR
EKTACHROME LUMIERE 100X Professional (LPZ)	CC05Y	None / No Filter		+$\frac{1}{2}$ stop / CC05B		NR

* The exposure increase includes the adjustment required by any filter(s) suggested.

† Short exposure times and/or the color quality of some electronic flash units may cause a bluish color balance on some daylight-type films. If your results are consistently too blue, use a CP10Y or CP20Y filter over the flash tube or a CC10Y or CC20Y filter over the camera lens.

Note: KODAK Color Compensating Filters (CC) are preferred for use with your camera. For less critical work you can use KODAK Color Printing Filters (CP).

NR = Not recommended for critical use.

Index